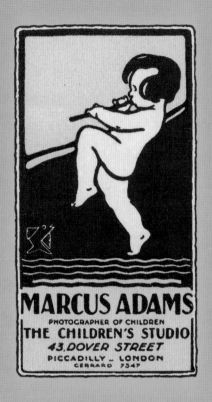

MARCUS ADAMS
PHOTOGRAPHER OF CHILDREN
THE CHILDREN'S STUDIO
43, DOVER STREET
PICCADILLY — LONDON
GERRARD 7547

MARCUS ADAMS
ROYAL PHOTOGRAPHER

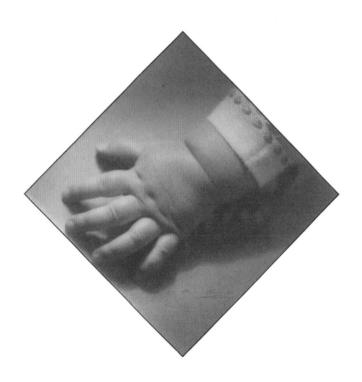

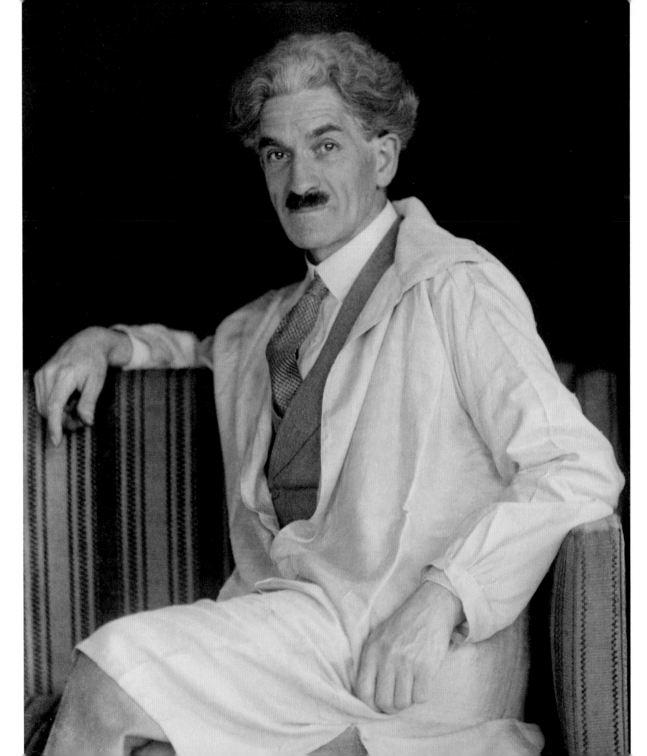

MARCUS ADAMS
ROYAL PHOTOGRAPHER

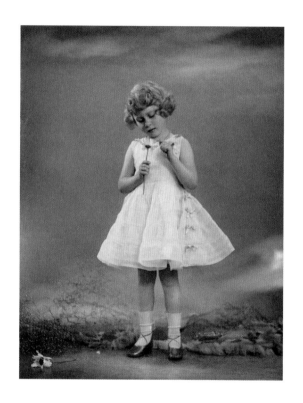

LISA HEIGHWAY

ROYAL COLLECTION PUBLICATIONS

Published by Royal Collection Enterprises Ltd
St James's Palace, London SW1A 1JR

For a complete catalogue of current publications, please write to the address above,
or visit our website on www.royalcollection.org.uk

© 2010 Royal Collection Enterprises Ltd
Text by Lisa Heighway and reproductions of all items in the Royal Collection
© 2010 HM Queen Elizabeth II

012350

ISBN 978 1 905686 20 9
British Library Cataloguing in Publication Data:
A catalogue record for this book is available from the British Library.

Designed by Peter Drew of Phrogg Design
Typeset in Garamond
Production management by Debbie Wayment
Colour reproduction by Altaimage, London
Printed and bound in Italy by Printer Trento
Printed on Gardapat Kiara

Sources for all quotations given in the text can be found on p. 113

Endpapers: *Logo for Marcus Adams's Children's Studio in London*
(RCIN 2943582.v): © The Estate of Marcus Adams

Half title: *Hand study, Princess Elizabeth,* 6 May 1927;
gelatin silver print (RCIN 2943710)

Frontispiece: *Marcus Adams, self-portrait,* 31 March 1927;
reproduced from an original glass plate negative (RCIN 2140664):
© The Estate of Marcus Adams

Title page: *Princess Elizabeth with flower,* 21 July 1931;
reproduced from an original glass plate negative (RCIN 2140710)

CONTENTS

6

LIFE AND WORK

20

ROYAL PHOTOGRAPHER

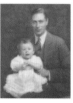

28

PRINCESS ELIZABETH'S
FIRST SITTINGS
1926–1929

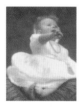

48

THE ROYAL SISTERS
1931–1935

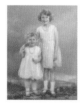

67

GROWING UP
1936–1941

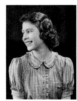

80

A NEW GENERATION
1949–1956

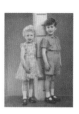

91

ROYAL RELATIVES

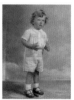

100

ROYAL PORTRAITS
BY BERTRAM PARK

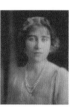

108

The Marcus Adams Collection
& Marcus Adams's Royal Sittings

110

Family Trees

113

Acknowledgements,
List of Sources
& List of Illustrations

120

Index

LIFE AND WORK

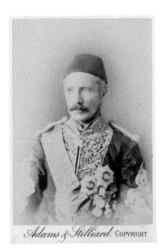

Cabinet print (and verso)
by Walton Adams of
General Gordon, 1882.

I'm glad I photograph children. There is a delightful natural charm with them that incorporates a lovable spirit of pluck, determination and a peaceful tranquillity. I regard photographs of our children in the Press, and perhaps especially the Royal Children, as some of the best ambassadors of good will we can have.

Marcus Adams, 'I Photograph Children', *The Listener*, 9 February 1939

Marcus Adams became internationally acclaimed for his portraits of children from all walks of life – most significantly, royal children. Indeed no other photographer is known to have devoted fifty years of their career to portraying children.

Adams was born in 1875, the third son and fifth child of photographer Walton Adams (1842–1934), who had opened his first studio in Southampton in 1864. Walton was associated with important early developments in photography; in the 1860s he had assisted Dr Richard Leach Maddox (1816–1902) in the development of the dry plate process, which from the late 1870s was to revolutionise photography. During his long career, Walton Adams photographed a great number of sitters, including Queen Victoria (Osborne House on the Isle of Wight being within easy reach of Southampton) and General Gordon (left). From Southampton Walton moved to Brixton for a short time; then in 1880 he and his wife Annie and their seven children moved to Reading, where he opened a new photographic studio on Blagrave Street.

Marcus Adams attended York House School in Reading until the age of fifteen, after which he secured employment

in a solicitor's office. Meanwhile he had started to attend classes at Reading College of Art, where his study of colour and tone served in later life to inform his photographic techniques. In 1892 he left the solicitor's office to become apprenticed to his father in the Blagrave Street studio. There he worked with two of his artistic siblings, his eldest brother Christopher, who was to become a painter and miniaturist, and his sister Elsie. Another sister, Lilian, also became a successful artist; she lived in Paris – a city Marcus loved to visit – and for many years exhibited at the Paris Salon. Marcus's years working in his father's studio gave him a thorough grounding in all aspects of photography at the outset of his career, which was to serve him well throughout his professional life.

By the early 1900s Adams was undertaking all types of photography. In his unpublished memoir 'Early Days', he recalled his first sitting: 'It must have been somewhere round 1899 or 1900 … Oh how I remember the dear lady in a flowered dress, she was a kindly sort,

results were very good.' His growing experience was broadened when he was asked to assist Charles Keyser (1847–1929) of Aldermaston Court near Reading, a writer on architecture and archaeology, and a wealthy landowner. Adams travelled around the country with Keyser, taking as many as a hundred photographs in a day of a particular building or church to illustrate Keyser's numerous publications. Among the churches they visited was that at Sandringham (right).

Sandringham Church, c. 1915, used to illustrate an article by Charles Keyser published in 1917.

Three generations of photographers. Left to right: Walton, Gilbert and Marcus Adams, c. 1908.

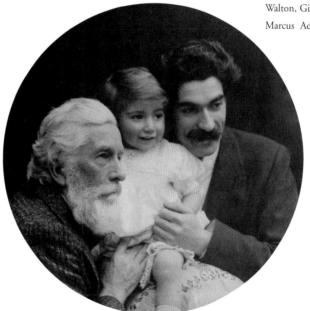

Adams's collaboration with Keyser lasted several years, during which many thousands of plates were made.

In 1904 Adams married Lily Maud Farr at the Wesleyan Methodist Church in Reading. In 1906 their only child, Gilbert, was born. He was to become a successful photographer like his father, and in 1953 he directed the lighting in Westminster Abbey for the Coronation of Queen Elizabeth II.

Marcus Adams took many photographs in and around Reading, local scenes as well as portraits. He was frequently commissioned to photograph particular events, for example the visit of King George V and Queen Mary to the Suttons Seed Factory in Reading

in March 1918 – his first encounter with royalty. However, it was for his portraiture that Adams was beginning to become known. He had been commissioned in about 1910 to photograph Sir Rufus Isaacs, Liberal MP for Reading; those portraits were so well received that he subsequently received two further commissions, to photograph the Prime Minister, H.H. Asquith, and the Chancellor of the Exchequer, David Lloyd George.

Adams had an instinctive rapport with children, whose company he genuinely enjoyed. He said: 'I am fond of children, fond of art, and love creating pictures. I realised in early years that the medium of photography was the best method of recording the fleeting expressions that glow over a child's face.' He soon began to encourage commissions for this line of work by producing advertisements for his Children's Studio (top right).

In 1911, for the first time, the London Salon of Photography accepted an Adams portrait for exhibition. The Salon's

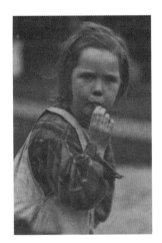

Young girl from Reading, *c.*1912.

Right: Barge on the River Thames opposite De Montfort Island in Reading, *c.*1910.

website announces its continuing aim today, 'to exhibit only that class of photographic work in which there is distinct evidence of artistic feeling and execution'. Also in 1911 'The Fairy Girl' and 'The Sunshine Boy' were published in *Photograms of the Year*, an annual publication that was to feature one or more Adams portraits regularly in the ensuing years (see p. 11). It was during this period that Adams, always innovative, developed what he called 'phase photography'. He would take a series of pictures of a child in varying poses, thus capturing a wide range of expressions. Each plate would be separately exposed, then all of them would be printed on a single sheet of paper, resulting in a 'group' portrait of one child.

After the outbreak of war in 1914 the Reading studio experienced staffing problems and the number of sittings began to dwindle. In order to make the most of a worsening situation, the Adamses decided to open a studio near Reading Station called The Khaki Studio, where they photographed servicemen. With another studio in the old Arcade, the family was now running three studios in the town, although Marcus himself only worked at 29 Blagrave Street. It was not long before he was called up for war work. He found lodgings in London and started to work in South Kensington for the Royal Flying Corps (later the RAF). One of his tasks was to produce instructional drawings and aerial

An example of Adams's phase photography, *c*.1905.

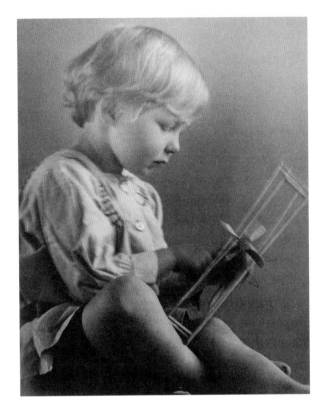

'Winding up my aeroplane', *c*.1910.

diagrams. He also had to illustrate scenes of aircraft in battle, in which his backgrounds were considered so good that he became known as 'the Cloud Monger'.

Much of Adams's spare time until he returned to Reading was spent at The Camera Club, at that time situated in John Street, Adelphi. Founded in 1885,

it is one of the most distinguished photographic societies in the world, and many prominent figures in the history of photography have been members. Adams would have been able to avail himself of their excellent facilities, which included a billiard room, library and dining-room. The Camera Club was to play a crucial role in Adams's career, for it was there that he met many established photographers. These included Bertram Park, an up-and-coming society photographer who had initially regarded photography as a hobby, but was fortunate to have a good friend in the 5th Earl of Carnarvon, who not only recognised Park's abilities and talent, but was prepared to lend him the essential funds for a business enterprise. (The Earl also financed a more widely known venture: the discovery of Tutankhamun's tomb.) And so in 1916, together with a colleague, Frank Buzzard (who was later bought out), the Earl and Park signed the lease for 43 Dover Street in Mayfair. Yvonne Gregory, photographer and miniature painter, was taken on as a photographic assistant and later became

Park's wife. The Earl of Carnarvon's confidence in Park was not misplaced; by 1919 profits were such that the money borrowed had been repaid.

Park had from time to time visited Adams at the studio in Reading and was impressed with his work. On 3 February 1919 Park wrote to Adams:

If you ever make up your mind to come to London, I would be quite willing to consider a business arrangement with you, myself. Ever since I have got thoroughly on my legs here I have constantly refused to do portraits of children, and I am being continually asked to. It is a pity that the people I send away should drift along to Speaights and so on. I have some capital at disposal, and I could have a large amount more if I wanted it, from several directions. I have had it offered to me several times but have preferred to get along by myself and do without outside help, or not more than necessary. I feel sure that if, for instance, we were to be associated in some way, that some of that capital could be, if required, deflected to your concern.

Adams was delighted. He had been thinking of trying his luck in London, and this offer gave him the means to do so.

There remained the rather difficult break to make from the studio in Reading. Adams's father was not encouraging, perhaps understandably as he would be losing a valuable member of staff. Although he did eventually come round to the idea, his view was that 'It is inconceivable that anyone should wish to work in a city full of wickedness'. In June 1919 an agreement between Marcus and Walton Adams was signed, ending their previous partnership but allowing Marcus to continue to receive any moneys due

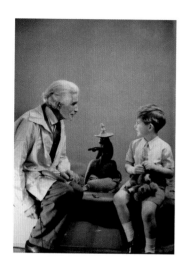

Marcus Adams with Prince Charles during a sitting in October 1953. Adams's right hand holds the bulb which operates the shutter to take this photograph.

to him from work he had undertaken while at Reading. He was now able to begin to make plans for establishing a Children's Studio in London.

Adams's 'Notes on the part I have played in the life of London' reveal his vision: 'to create a studio with an atmosphere suitable not only for the child but one that was to become a part of me. It had to be bright and a very happy play room [where] each child could enjoy the period of the sitting and take away the joy of having paid me a visit.' He decided to devote the best part of a year to designing and constructing his studio – as well as his unique cameras. Adams's aim was to create a studio that would bear no resemblance to a conventional one; there would be no visible cameras or tripods, no dazzling lights. Instead he filled shelves with things that would arouse a child's curiosity, anything from a trick banana to soft toys, beautiful stones and mechanical gadgets. He would thus enable the camera to capture the response to the distraction. He believed that, in order to obtain an uninhibited likeness, it was

essential that the child should be free from any kind of apprehension; he therefore aimed to create a relaxed and colourful world in which the sitter would feel completely at ease.

Colour was extremely important to Adams; this was reflected in his studio, where the reception area was yellow with a blue ceiling, and the studio itself full of colour. Adams wrote:

When I designed The Children's Studio in Dover Street, I carried certain patterns and colours and kept them in my pocket for weeks to test the effect on different people and a number of children. My object was to create a complete scheme to stimulate the little subject to realise the instant they entered the studio it was a room for them and one and all loved it. Thus my work became much easier and certainly much more of a joy to work in such a delightful atmosphere of colour. The colours were brilliant, but very carefully blended so as not to clash, this was to avoid any discontenting note that would excite unduly …

He had already constructed a camera for the Reading Studio which was built into a cavity in the wall; this space was big enough to house his assistant, who would change the plates and keep the camera in focus. His London camera, like the Reading one, was an odd-looking piece of equipment; it resembled a toy cabinet, a piece of furniture which most people, especially children, would not recognise as a camera. This unconventional design, which housed two lenses, enabled Adams to move about with a length of rubber tubing at the end of which was a bulb that, when squeezed, would operate the shutter. The studio assistant would then quickly and quietly change the plate ready for the next picture. Adams considered most 'regular' cameras quite unsuitable for photographing children; he thought 'the shutters are enough to scare the life out of a child'. Nor did he like to use the customary black cloth under which the photographer would disappear to take their shot, thus drawing attention to the camera, something Adams aimed to avoid at all costs: 'I want the child's attention on **me** and not on the camera', he wrote

in *The Listener* in 1939. That the subject should be as oblivious to the camera as possible is a view that Lord Snowdon shares: 'Someone who buries his head in a black cloth or an enormous view-finder may think he's invisible, but he's oppressively there to everyone else. And so whatever he's photographing gets frozen and staged, and turns into a piece of theatre.' Adams believed that the photographer should be so familiar with his camera that its operation would be completely instinctive, allowing him to concentrate on his subject in order to secure the finest results. He maintained that 'photography is ninety-five per cent psychology and only five per cent mechanical'.

Some examples of Adams's logos for The Children's Studio in London.

One of Adams's negative books, covering the years 1920–29.

we know that among those photographed during the first year were the children of Lady Evelyn Guinness, Lady Violet Astor and the Countess of Ronaldshay; and also that Princess Elizabeth's first sitting was in 1926. The success of these early sittings generated further bookings – by word of mouth, repeat visits, and from Adams's exposure in journals and magazines such as *The Illustrated London News* and *Sketch*. When the children Adams had photographed grew up, they returned to the studio with children of their own. By the end of his career Adams had photographed two or more generations of several families. A trip to Dover Street became an annual event for many children at this time.

There was no predetermined plan for a sitting, nor was there a time limit. Adams would take as long as was required, although usually up to an hour would be sufficient. As soon as the child entered the studio they would, to all intents and purposes, be left to their own devices and allowed to play with any toy of their choice.

The Children's Studio in London opened early in 1920, and from the start it flourished. There were now three photographers of considerable distinction at 43 Dover Street – Bertram Park, Marcus Adams and Yvonne Gregory – sometimes referred to as the 'Trinity of Dover Street'. The timing of the opening was fortuitous. Adams was able to fill the gap between the demise of the painted portrait and the arrival of the amateur camera, which would enable every parent to record their children's early years themselves. From Adams's negative books

Parent or nanny would wait in a dressing area (there would often be a change of clothes during a sitting), partitioned from the studio by a glass screen which allowed a view of what was going on. They were not encouraged to enter the studio, where they might suggest a pose or try to adjust a child's hair or clothing – interference that could ruin the relaxed atmosphere or make the child self-conscious. Adams, wearing his light-coloured artist's smock, would spend time with his charge, talking, listening, moving props, generally becoming friends with the child and waiting for the moment to capture an expression, a laugh or a particular gesture. Occasionally the child would not respond to any of the toys or conversation. Adams recalled:

I remember one child of three and a half who stood solidly in the middle of my studio and would not yield to any inducements to play or talk – a hopeless position. I left the studio, told the nurse to have a good romp, and that I would come back in ten or fifteen minutes. When I returned, matters were different: all was

Marcus Adams working with a young child, 1935. In each of these three photographs it is possible to see where Adams marked the glass plate to indicate how much was to be cropped on each side to produce the image he wanted.

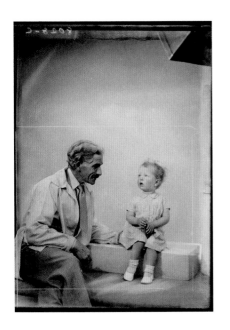
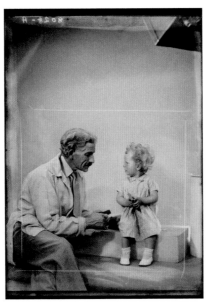
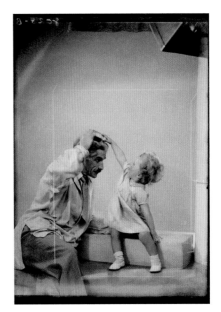

well. Afterwards I discovered mother had told the child to stand still for a photograph and 'do as the man told her', undesirable obedience. When the child was free and happy the whole atmosphere was perfect.

The sittings books, or negative books as Adams called them (see p. 14), provide a fascinating insight into his daily work. Each sitting is numbered; the family name is recorded, followed by the date of the sitting. The name of the child or children to be photographed is entered, together with any notes – perhaps relating to the child's age and colouring (whether fair, medium or dark), to the type of portrait required (a single portrait, or a group to include the parents) or to the fact that it is a re-sit. The delivery date is also noted, sometimes with a reminder that the order is urgent, or to be posted, or just that it is needed quickly.

Throughout his life Adams photographed children from many different countries and from all walks of life. Reading down the list of names in his negative books, we find that those visiting his studio were for the most part children of the rich and famous. Their parents were part of the Establishment or of the literary or theatrical life of London, or indeed royal – the books include names such as Bowes Lyon, Rothschild and Tavistock; and the children of Mrs A.A. Milne, Gertrude Lawrence, Yehudi Menuhin and Agatha Christie, to mention but a few. Another regular entry in the negative books is 'Vacani'. Madame Vacani,

Sketches and watercolours dating from Adams's 1904 visit to the Middle East, depicting street scenes in Nazareth and Bethlehem.

described by Adams as 'one of the most ravishing women I have ever met', founded the Vacani School of Dancing in 1915 and was the energetic organiser and producer of the annual charity matinées that were a highlight of London children's social calendar. She also took charge of the dance and ballet element of the royal pantomimes at Windsor Castle in the early 1940s. Her pupils included Princess Elizabeth and Princess Margaret, and later Prince Charles and Princess Anne. Literally hundreds of children were involved in each matinée, and Adams's photographs of them in their costumes were reproduced in magazines and periodicals available before the start of each show.

Marcus Adams was a perfectionist; nothing was left to chance. Having set up his studio, built his camera, organised the lighting, engaged with the sitter and released the shutter, he continued to supervise every step in the production of a print. Each of the three photographers at Dover Street had their own studio as well as their own technicians, but they

shared the various processing facilities. Adams's unique balance of tonal and focal quality was a result of several factors, including his particular combination of lenses in the camera and his paper, which was coated to his own specification. During a full working day as many as a thousand glass plates might be processed. The finished prints would be dry mounted, then signed by Adams, signifying his approval. Finally the photographs would be enclosed within a tissue folder and secured with a red seal, ready for delivery to the client.

An avid traveller, Adams regularly ventured abroad, either by himself or more often with his wife, Lily Maud, or his brother Christopher. In 1904, shortly before he married, he had saved enough money to travel to the Middle East. Throughout the trip he not only took photographs but also sketched and painted, recording scenes as he travelled.

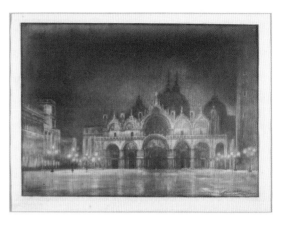

St Mark's Square photographed during a visit to Venice in 1953. Adams has worked on the negative to create the effect he wanted for this 'Night Picture'.

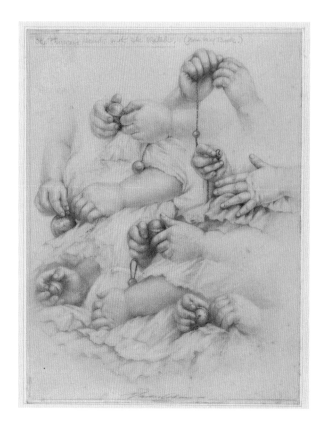

It is possible that in other circumstances Adams might have been an artist first and photographer second, rather than the other way round.

In 1935 his book *The Rhythm of Children's Features* was published. It is dedicated to Her Royal Highness Princess Elizabeth of York and includes reproductions of two pencil studies by Adams of the infant Princess's hands (left). Adams had a particular interest in phrenology, palmistry and psychology. Writing about hands, he says: 'Their many indications, shapes, textures, forms, colour and lines all have a truth to unfold if we be wise enough to understand and learn the language written thereon.' As far as photographic portraiture was concerned, he said: 'Where possible always include the hands, they are just as attractive and expressive as the face, and add greatly to the interest of the picture.'

The number of sittings declined during the Second World War, and at one point The Children's Studio closed altogether because so many children were evacuated from London. Adams was undaunted. He built a portable camera (right) which, although rather heavy, was relatively easy to transport and which enabled him to travel around the country, visiting family homes. He found that his portraits were in demand – perhaps partly owing to a feeling of uncertainty about the future, parents wanted a tangible memento of their children.

Adams was by this time well into his sixties, and travelling around the country with a camera was physically demanding. The work began to take its toll and Adams suffered several periods of ill health.

Life was very different in post-war London. There was a pervading air of austerity, and as amateur photography became more popular, studio bookings dwindled further. The situation was not helped by the fact that the premises at Dover Street were becoming more expensive, and that it was proving more and more difficult for Adams to obtain his special paper from Kodak. Relations between Adams and Park began to deteriorate. A particular blow to Adams was the discovery that, during one of his absences from the studio due to ill health, Park had disposed of several thousand glass negatives, which included some of Adams's finest work. Their partnership never really recovered; Adams's final sitting at 43 Dover Street was on 7 February 1958.

Adams was a man of tremendous energy: he had always been interested in elevating the status and working conditions of photographers, and he sat on various committees. His numerous appointments included that of Honorary Fellow of the Royal Photographic Society, Founder Fellow of the Institute of British Photographers, member of the London Salon of Photography and President of the Photographers' Professional Association, as well as being a member of the Reading Group of Artists and the St Ives Society of Artists. He lectured widely and exhibited regularly, often to great critical acclaim.

Adams spent his last few years near Wargrave in Berkshire, where he painted, enjoyed his garden and observed the natural world around him. He died in 1959, aged eighty-four – a remarkable man whose legacy remains a significant and unique contribution to British portrait photography. 'By his integrity and tenacity', said a president of the Institute of British Photographers, 'no man has done more to raise the dignity of photography than Marcus Adams.'

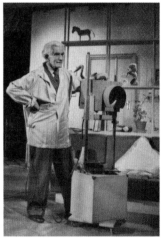

Marcus Adams with his travelling camera, designed and built by himself, c. 1939.

ROYAL PHOTOGRAPHER

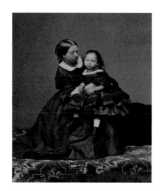

Queen Victoria and
Princess Beatrice, May 1860,
by J.J.E. Mayall.

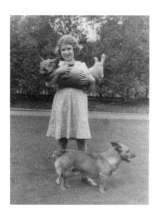

This delightfully informal
photograph of Princess Elizabeth
was taken in 1936 by Studio Lisa
in the garden at 145 Piccadilly,
the London home of the Duke
and Duchess of York.

Since the earliest days of photography, royal photographs have always been much in demand. Queen Victoria was the first member of the Royal Family whose portrait was widely distributed. In 1860 J.J.E. Mayall photographed the Queen, the Prince Consort and their children, and the resulting portraits were published as cartes-de-visite. Their small format and relative cheapness meant that the general public could, for the first time, afford royal portraits for their own homes. This demand for royal images has continued to the present day.

Prior to the First World War, royal portraiture was generally a serious affair, presenting a carefully crafted image to the public. The sitter seldom appeared to be at ease, and any spontaneity of expression was rare. Relaxed informality was not for the public eye; that could be found only in private family albums. Marcus Adams transformed the royal portrait and, over the course of thirty years, created a unique photographic record of two generations of royal children. His was a fresh, natural, vibrant view of royalty, and the wide dissemination of many of his portraits in newspapers and magazines brought the Royal Family closer to their subjects than ever before. Adams was not the only photographer to receive royal commissions at this time. Like him, Baron, Studio Lisa, Cecil Beaton and Speaight – and Bertram Park – each had their own distinctive style, and filled a particular niche in the market. Adams was first and foremost a studio photographer who, uniquely, concentrated on photographing children. His studio, his cameras and his whole approach to a sitting were created with this end in view. New images by other photographers, therefore, were not considered competition. While Adams worked in the studio, different photographers would be

called upon to attend weddings or christenings, or to take informal pictures of families at home. And in addition, there were a number of amateur photographers within the Royal Family – including King George VI himself.

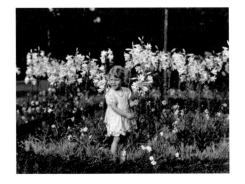

As well as almost exclusively confining his work to the studio, Adams imposed on himself a rule that he would not work with subjects over sixteen years of age (although he did allow parents to appear with their children). As a result of this self-imposed rule, Adams was unable to grant a request from the Countess of Strathmore to photograph her daughter, Lady Elizabeth Bowes Lyon, when she was over sixteen years old. He did say, however, that if she married and had children, he would be delighted

to photograph them. This, of course, is exactly what happened. Lady Elizabeth Bowes Lyon married the Duke of York (later King George VI) on 26 April 1923. Princess Elizabeth was born on 21 April 1926 at 17 Bruton Street, the London home of the Duchess of York's parents, the 14th Earl and Countess of Strathmore and Kinghorne. It was just a few months after the Princess's birth that Marcus Adams was invited to Bruton Street to make arrangements for what was to be the first in thirty years of royal sittings.

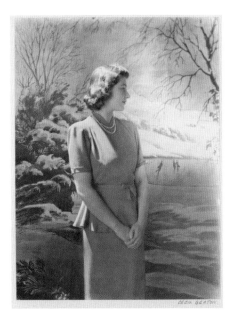

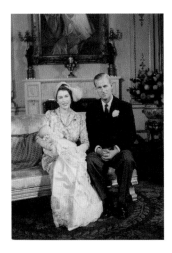

Princess Anne, born on 15 August 1950, was christened at Buckingham Palace on 21 October 1950. On this occasion Baron was commissioned to take the photographs.

Far left: Princess Elizabeth surrounded by lilies, 1929, photographed by her father the Duke of York (later King George VI).

Left: Princess Elizabeth, now over the age of sixteen, was photographed in March 1945 by Cecil Beaton.

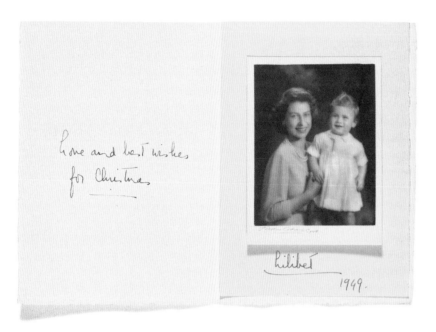

Love and best wishes
for Christmas

Lilibet

1949.

Today has been very special. At about 2.45 this afternoon I was introduced by Mr Adams to Princess Elizabeth in the capacity of his assistant. This was the culmination of a long-awaited hope. The realisation of it was clinched last Wednesday when Princess Elizabeth's lady-in-waiting arranged an appointment with Mr Adams for the taking of Prince Charles with his mother. Great was the cleaning and polishing that followed and today the studio looked perfect with Mr Park's beautiful chrysanthemums as the finishing touch.

So successful were the results from Prince Charles's first sitting with Adams that this image was chosen by Princess Elizabeth as her Christmas card for 1949.

The Children's Studio benefited considerably from Adams's royal patronage, not just in terms of increased business, but also by gaining an enhanced reputation worldwide. Before a royal sitting, staff at the studio would make an extra effort to ensure that everything was in order, not merely checking that the equipment was 'ready to go', but also such things as arranging fresh flowers to welcome the visitors. Sylvia Bennett, Marcus Adams's assistant, gives us a first-hand account of such an occasion in her diary for 26 October 1949:

Excitement reached fever pitch when at last the Princess arrived at 2.30 with Nurse Lightbody and the baby. The sitting went off perfectly. Prince Charles laughed and smiled. Princess Elizabeth smiled and laughed and chatted to everyone, including me, so naturally. She is really charming. The time passed all too quickly, despite the fact that we were in the studio over an hour and a half. Miss Newcomb was very thrilled when she was given Prince Charles to hold while the Nurse collected all her belongings. I amused him with a silver rattle while he waited. He chuckled

and held on to my finger. Both Mr Vintner and I received another handshake as she left. A very emotional Mr Adams kissed me in the studio when all was over, and I thanked him for the honour I had received at being present at such an auspicious occasion. He has now taken two generations of [children of] the Royal Family. Now the fun really starts. Our pictures will be used for the Prince's birthday. Life's going to be hectic …

Prince Charles celebrated his first birthday on 14 November 1949. On 13 November Sylvia Bennett noted in her diary:

Our pictures of the Princess and her baby came out in all the papers today. In these last few days all of 43 [Dover Street] have been working on and sending out over a thousand prints. I have never known such a commotion from Fleet Street, directed at us. To start this week we have to get out over three hundred by Tuesday for press release. I don't know when it will lessen. In America they would have the same positions in their Sunday papers. They were radioed out there.

The hard work involved in a royal sitting was not limited to the sitting itself and the production of prints. Adams would have to go to Buckingham Palace, where he would discuss with the parents the distribution of prints. Some might be kept for private purposes, some were for publication or to be used for a foreign tour, while others would be used to satisfy a variety of commercial demands – images for post cards, calendars, commemorative china, even biscuit tins and jigsaw puzzles.

The delightfully relaxed mood of Adams's portraits of the Royal Family was achieved in part by their willing co-operation; there was no standing on ceremony,

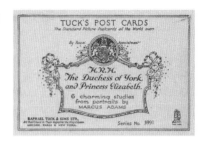

Below: A two-handled mug produced to commemorate the Coronation of King George VI and Queen Elizabeth in May 1937. The family portrait by Adams reproduced on this mug had been taken in November 1934.

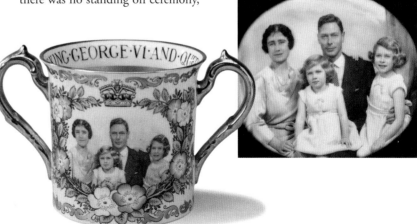

Above: The photograph reproduced on this souvenir cup and saucer was taken by Adams in June 1927.

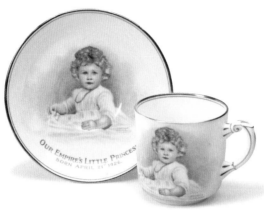

Taken to celebrate Prince Charles's fourth birthday, this is one of many Adams images reproduced by Tuck on a post card. (Prince Charles and Princess Anne are taking a great interest in the same Victorian crystal watch that intrigued their mother as a child; see p. 18.)

whether the sitting took place at Dover Street or, as it occasionally did, at one of the royal residences. Sometimes the children would arrive first, accompanied by their nurse (as nannies used to be known). The sitting might be well under way when their mother would appear, quietly and unannounced, and sometimes their father as well. Group portraits would then be taken with one or other of their parents, or all together. Adams always called the royal children by their first names; like other young sitters they

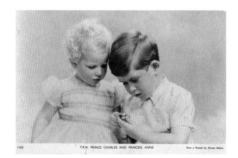

usually called him Mr Adams or even Mr Golliwog (perhaps on account of his fine head of hair!). As many as two hundred plates were exposed during a typical sitting. Many of these would be rejected, but there would always be at least fifty successful images. Adams maintained an extremely good relationship with both Clara Knight, nurse to Princesses Elizabeth and Margaret, and Helen Lightbody, nurse to Prince Charles and Princess Anne. Of Clara Knight he noted: 'Whenever the Princesses come here they are always accompanied by Mrs Knight who not only is a wonderful woman, but also one of the most remarkable Nurses I have ever met – and, as you can guess, I've met a lot!'

Following a sitting with Prince Charles and Princess Anne on 23 July 1953, after the Coronation and before Princess Anne's birthday, Adams wrote to his son Gilbert:

Just a line after another Royal Sitting of Charles and Anne. I hope I have some good results. Arrived late, 3.15, left at 4.45.

We all had tea in the studio. The nurse reserved the Coronation Dress & Page suit for me to do, she prevented 'Baron' from taking them together (good of her). They were sweet and Anne very helpful … I am working to make pictures of them during the Australian trip, to send monthly. The nurse and Queen were talking it over yesterday. It's good it came that way, so I said yes I would be delighted to repeat History [see p. 34]. Newcomb says that I have a wonderful friend in Lightbody, she can't say enough in my favour … I hope to see the Queen next week with the proofs.

Many members of British and European royalty attended the studios at Dover Street, where Marcus Adams photographed the children and Bertram Park the adults (see pp. 100-07). Adams's sitters included Prince William of Gloucester with his father; Prince Edward and Princess Alexandra of Kent; the Infantas of Spain, Beatriz and Maria Cristina; and the sons of Princess Paul of Yugoslavia. Among those taken by Park were Queen Mary; the Duke and Duchess of York; the Prince of Wales (later King Edward VIII);

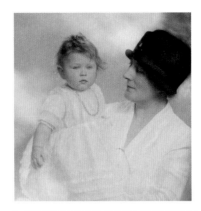

Nurse Clara Knight with Princess Elizabeth, photographed by Adams in March 1927. The Duke and Duchess of York were on their tour of Australia and New Zealand at the time.

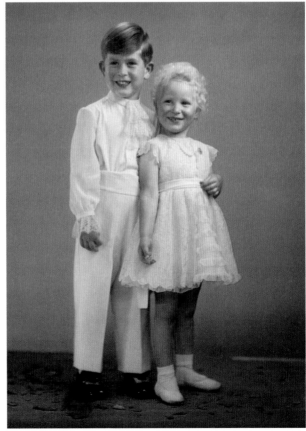

Prince Charles and Princess Anne wearing the clothes they wore for their mother's Coronation on 2 June 1953.

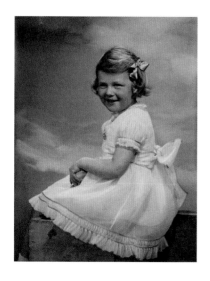

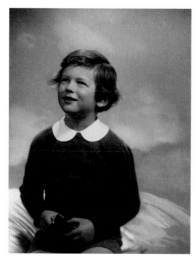

Princess Alexandra of Kent,
April 1940.

Above right: Prince Edward
of Kent, April 1940.

Right: Prince Henry, Duke of
Gloucester, with his elder son,
Prince William, October 1943.

George, Duke of Kent; and Marina,
Duchess of Kent, with her sisters Olga
(Princess Paul of Yugoslavia) and
Elisabeth. Also from Europe were King
Peter and his mother Queen Marie of
Yugoslavia, King George II of the
Hellenes and Queen Victoria Eugenia
of Spain.

Adams always considered himself
extremely privileged and honoured
to have had the opportunity of making
exclusive portraits of the royal children.
'I have made hundreds of pictures
of them from their earliest babyhood …
it has been a real joy to me to watch the

ever changing phases of their young lives.'
In 1953 Adams was invited to introduce
the Coronation film *Elizabeth Is Queen*,
produced by Pathé Films. He was shown
seated at a desk, turning the pages of an
album containing some of his portraits of
the new Queen as a child. There were
several close-up shots of toys he had used
to amuse the young Princess while he
took the photographs – toys that could
also be seen in the photographs
themselves. Being on the other side of the
camera was to Adams rather daunting;

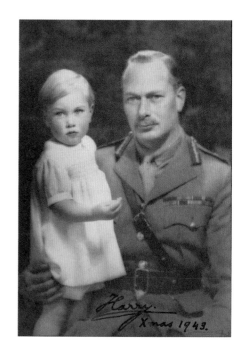

he noted: 'It was an ordeal for me but one that was making history and therefore worth the while.'

At the start of his 'royal' career Adams was already over fifty, and by its end when he was photographing Princess Anne in 1956 he was over eighty. It is unfortunate that he did not live to be able to complete his portfolio of royal portraits by photographing The Queen's two youngest children, Prince Andrew and Prince Edward. However, he was the recipient of two Royal Warrants, from Queen Elizabeth in 1938 (bottom right) and from The Queen in 1956, fitting endorsements of his fine work in child photography. Of his long association with the Royal Family Adams said, 'I have had more joy from that family than from any. They are full of fun.'

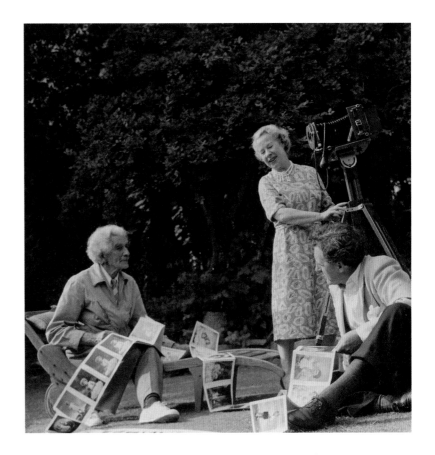

Marcus Adams reviewing some of his royal portraits with royal biographer Dorothy Laird and photographer Eric Coop, *c.*1958. Photograph by Gilbert Adams.

Left: Adams was granted a Royal Warrant from Queen Elizabeth in 1938.

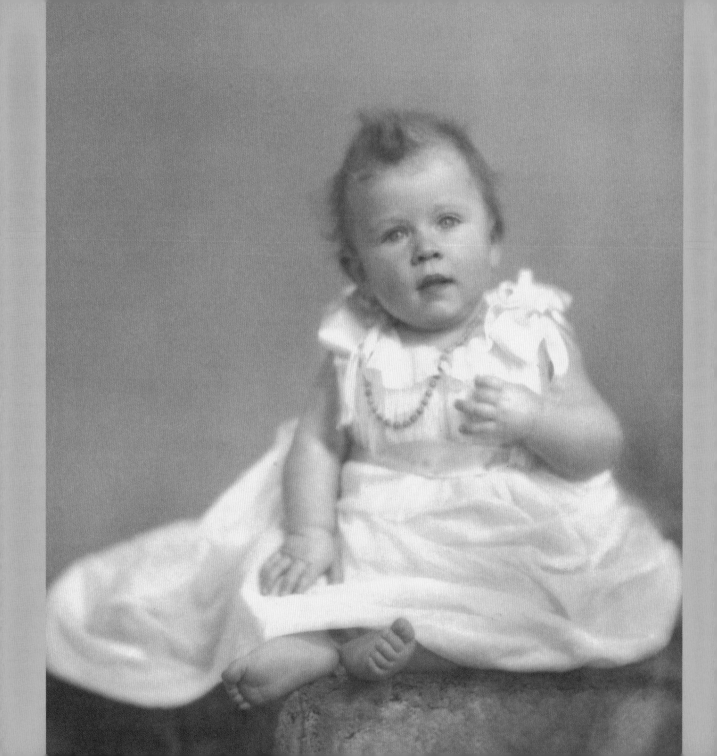

PRINCESS ELIZABETH'S
FIRST SITTINGS

1926–1929

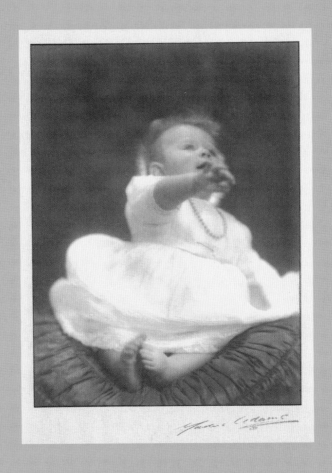

1926

Princess Elizabeth's first sitting with Marcus Adams took place on 2 December 1926, when she was just over seven months old.

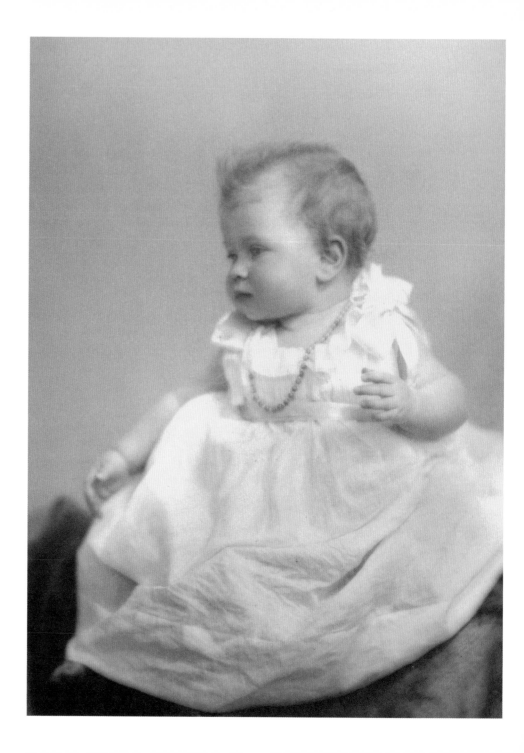

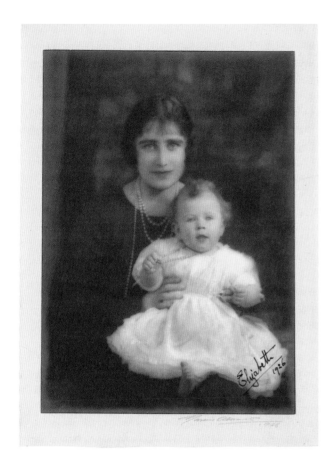

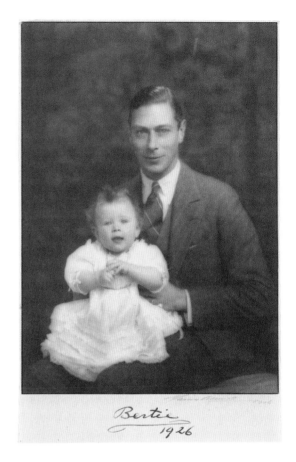

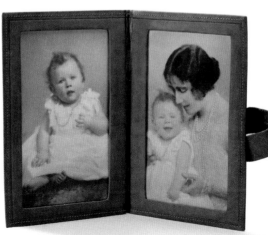

This small leather double-frame, with two photographs from Princess Elizabeth's first sitting with Adams, belonged to the Duchess of York.

1927

On 6 January 1927 the Duke and Duchess of York (later King George VI and Queen Elizabeth) sailed from Portsmouth for Australia and New Zealand, where the Duke was to open the Commonwealth Parliament in the new Australian capital of Canberra. Princess Elizabeth was just over eight months old. The Duchess wrote in her diary for that day: 'Feel very miserable at leaving the baby. Went up & played with her & she was so sweet. Luckily she doesn't realize anything.'

During the first sitting after the Duke and Duchess of York's departure in January 1927, Princess Elizabeth was pictured playing with a pair of Victorian glasses, and was also given photographs of her parents to look at to keep their faces familiar whilst they were away.

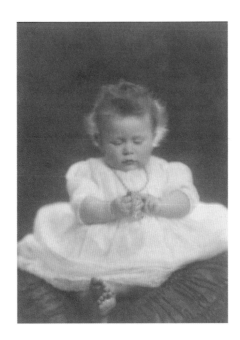

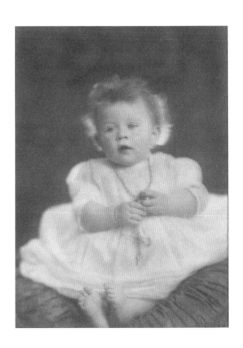

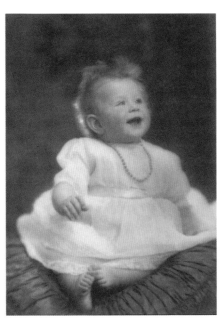

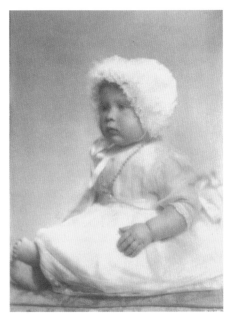

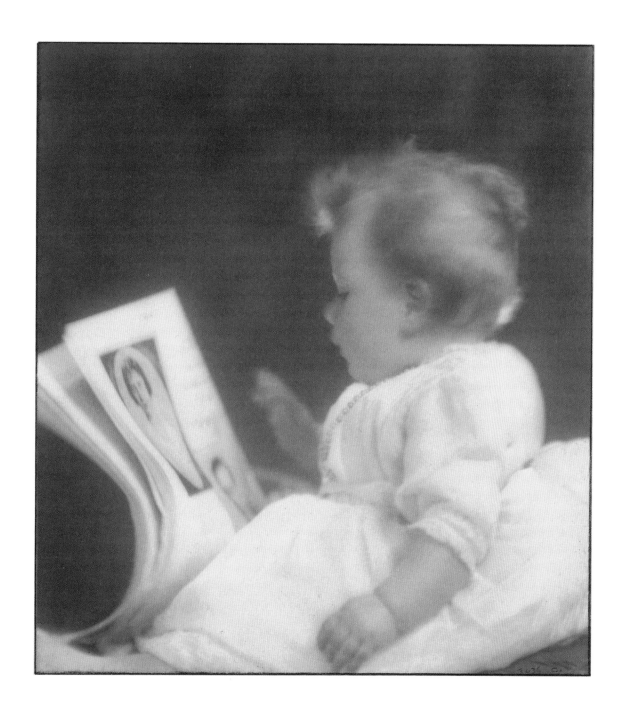

1927

The Princess was taken to four
sittings with Marcus Adams
while her parents were away –
one in January, two in March
and one in May (the Yorks
returned from their travels in
June). The photographs from
these sittings were sent to the
Duke and Duchess, enabling
them to see their daughter's
development and to be
assured of her well-being.
On their return they thanked
Adams and confessed that
the photographs were always
the first thing they pulled out
of the royal dispatch bag.

The photographs taken in
early March include a back
view of the Princess. Adams
may have thought that parents
would want to see their child
from every angle, a back view
being just as important as a
front view.

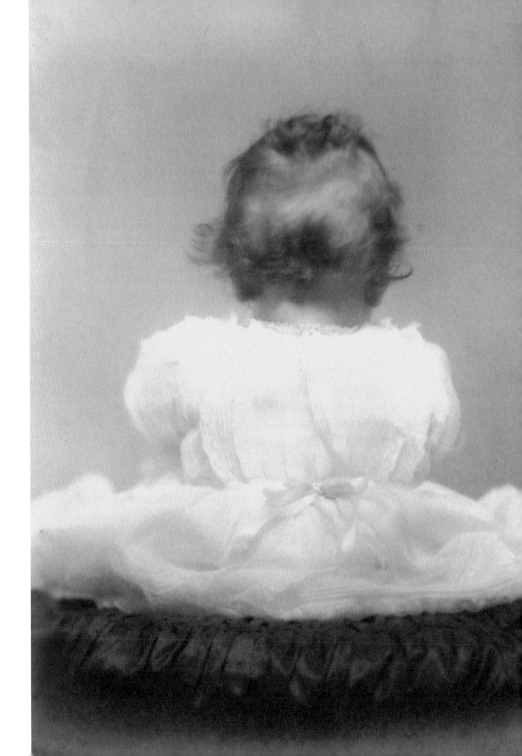

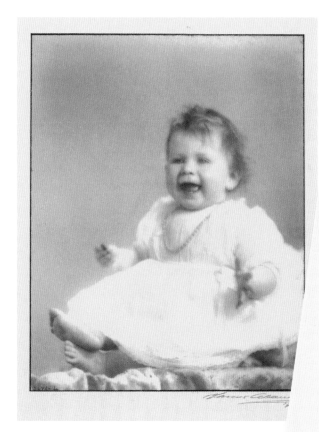

Nurse Knight wrote the note below to accompany this picture of Princess Elizabeth.

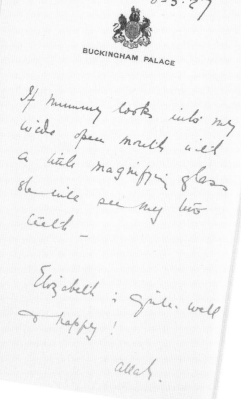

8-3-27

BUCKINGHAM PALACE

If mummy looks into my wide open mouth with a little magnifying glass she will see my two teeth —

Elizabeth is quite well & happy!

allah.

1927

During her parents' six-month absence, Princess Elizabeth was cared for by her grandparents and her nurse, Clara Knight, known as Allah. She stayed first with her maternal grandparents, the Strathmores, at St Paul's Walden Bury in Hertfordshire, then in February she went to London to stay with King George V and Queen Mary.

Queen Mary took the Princess to The Children's Studio at the end of March. The resulting photographs include this one of Princess Elizabeth sitting happily on her grandmother's lap.

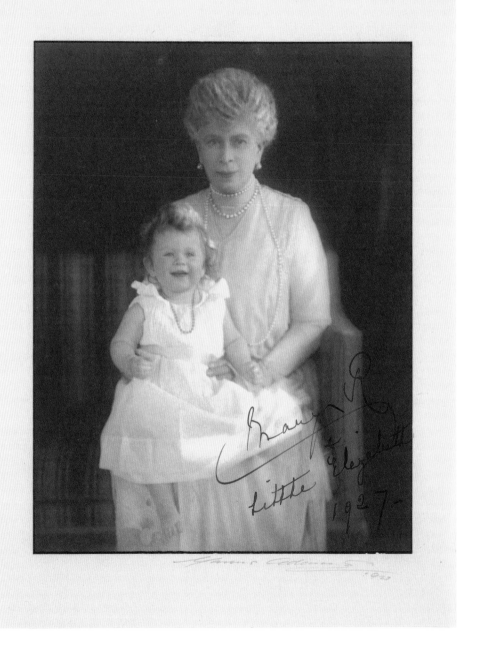

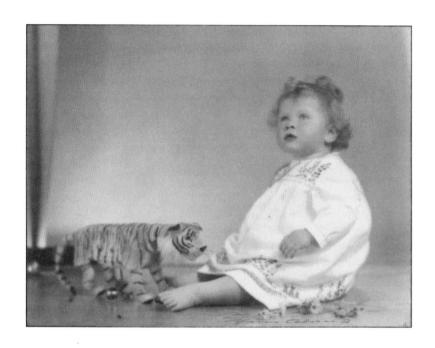

The final sitting with Adams before the return of the Duke and Duchess of York was at the beginning of May. The many successful pictures include a study of the Princess's hand.

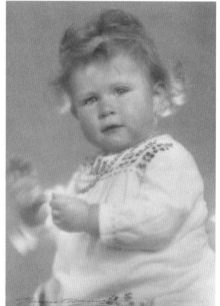

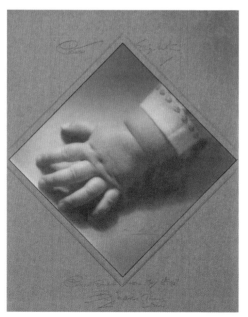

1927

Just three days after their return, on 30 June, the Duke and Duchess and Princess Elizabeth were once again in front of Adams's camera. The resulting portraits show both parents full of smiles as they pose with their daughter, who was by then able to stand on her own.

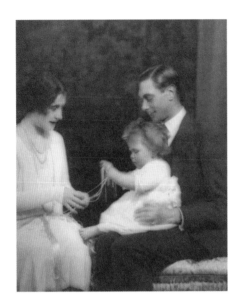

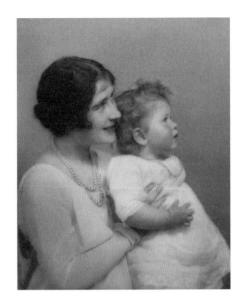

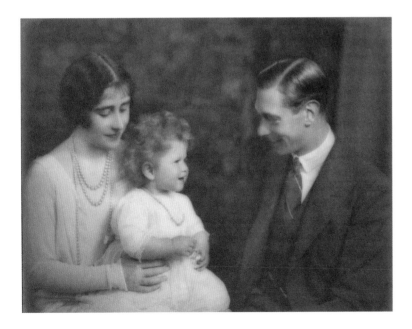

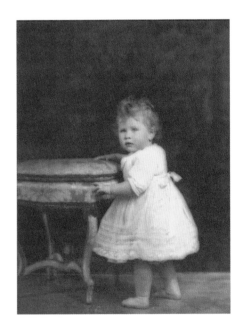

1928

In July 1928 Adams took a series of what are now some of the most well-known portraits of the Princess. It is said that Princess Elizabeth was delighted with this image, so much so that she later asked if her sister Margaret could be photographed in a similar pose. This duly happened in 1933 (see p. 59). The artist, Miss Buchanan Scott, painted this miniature after the Adams portrait.

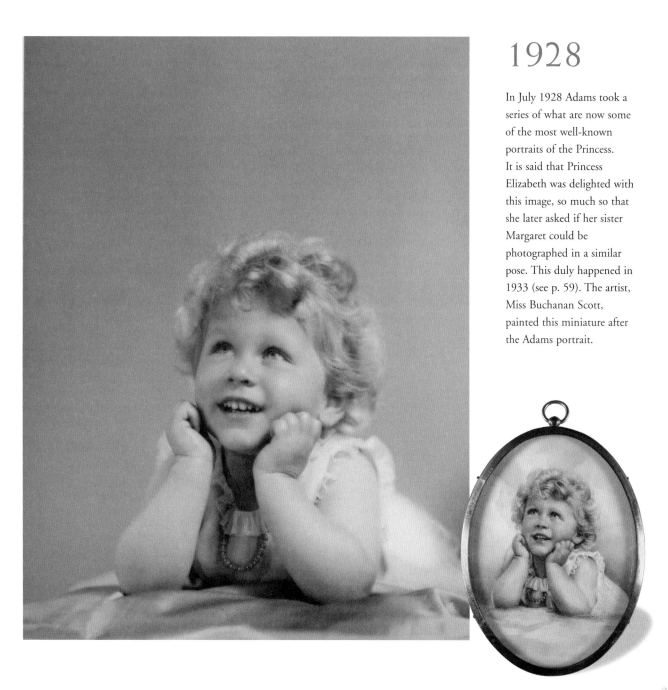

1928

A coloured version of the photograph below was produced in pastel by Christopher Adams, Marcus's eldest brother, in 1931. In 1857 Prince Arthur, Queen Victoria's third son, had been photographed by Caldesi in a similar attitude, a pose reminiscent of the two putti in Raphael's *Sistine Madonna*.

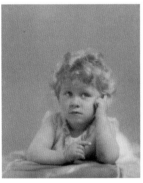

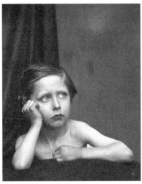

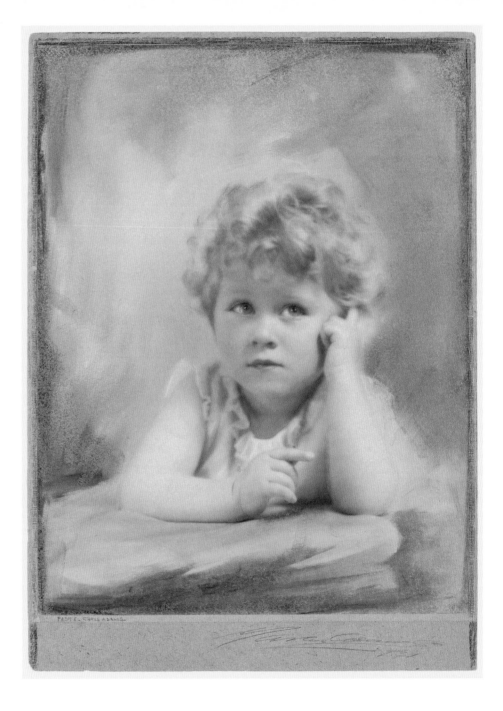

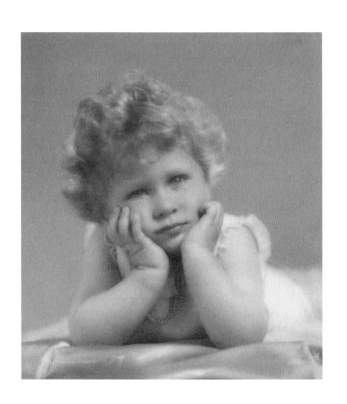
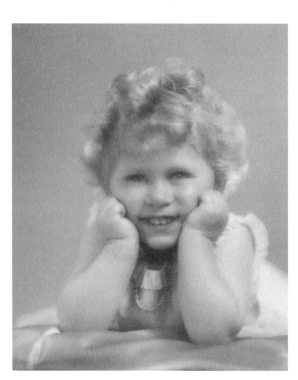

1928

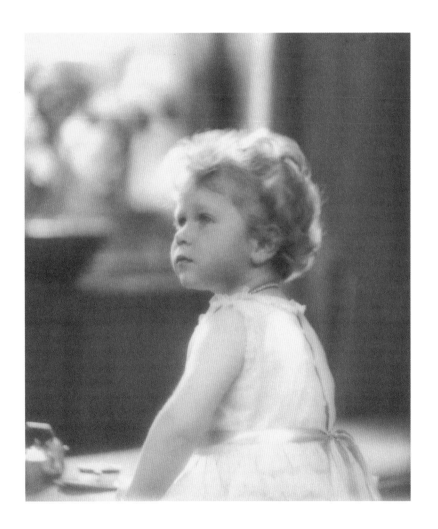

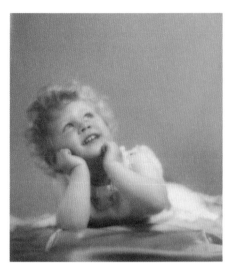

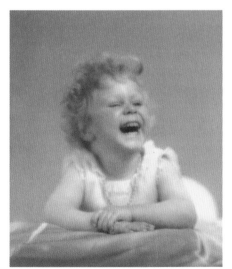

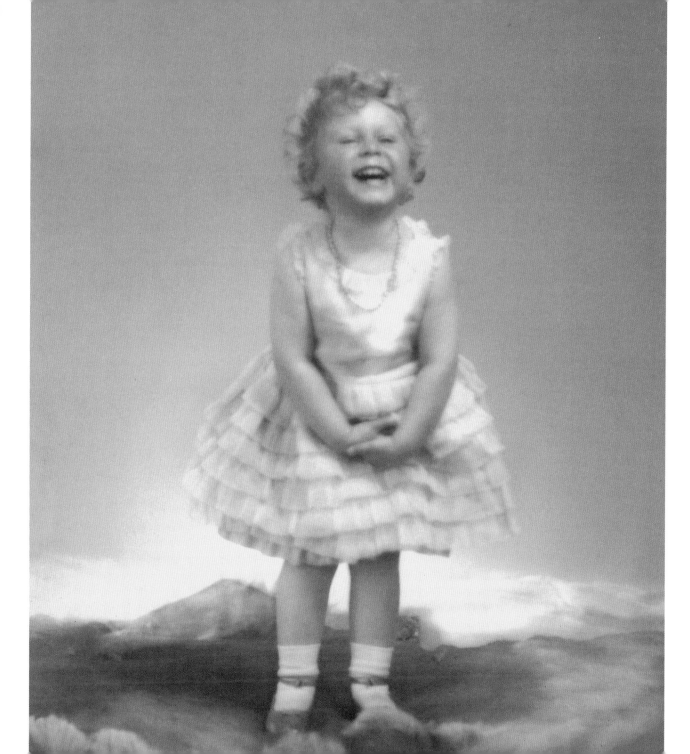

1929

The whole family attended a sitting in July 1929. In one of the photographs the three-year-old Princess Elizabeth is pictured sitting on a table on which there are some dolls and a tea set – some of the many toys used to amuse the studio's young sitters.

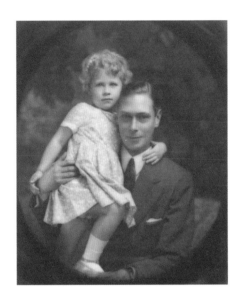

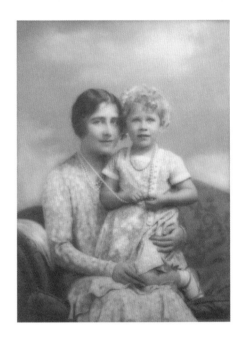

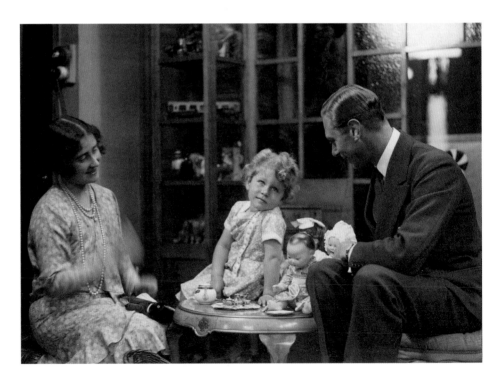

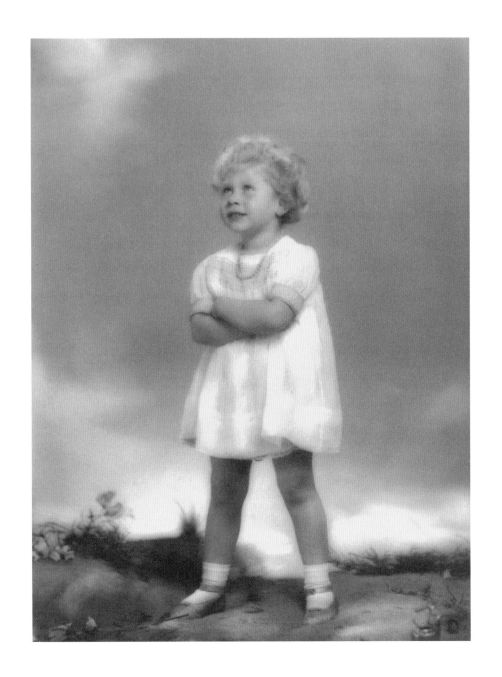

1929

This photograph of Princess Elizabeth was taken in November 1929. Adams has worked on the negative to create one of his distinctive dark backgrounds, enhancing the effect of the highlights in the Princess's hair. This image was chosen for Newfoundland's 6-cent stamp issued in 1932 – the first portrait of the Princess to appear on any postage stamp.

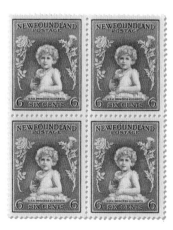

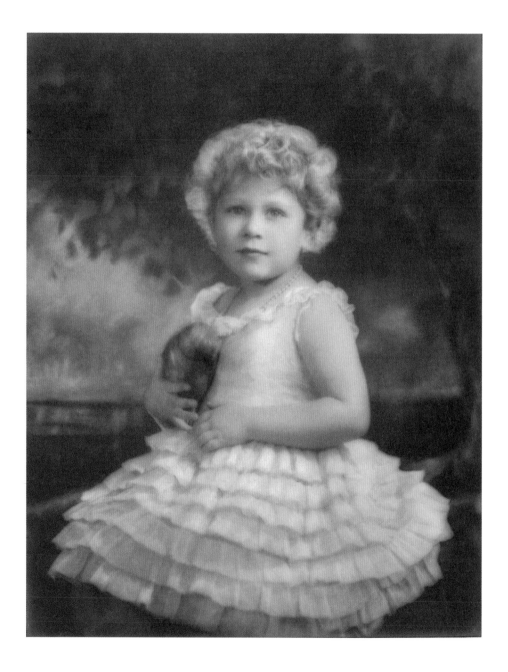

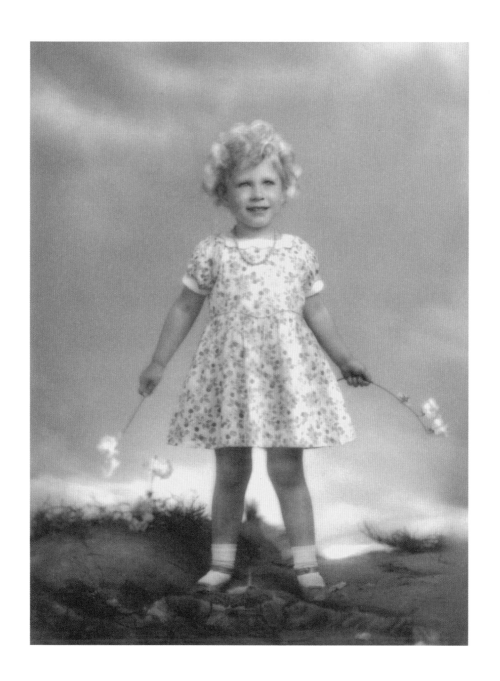

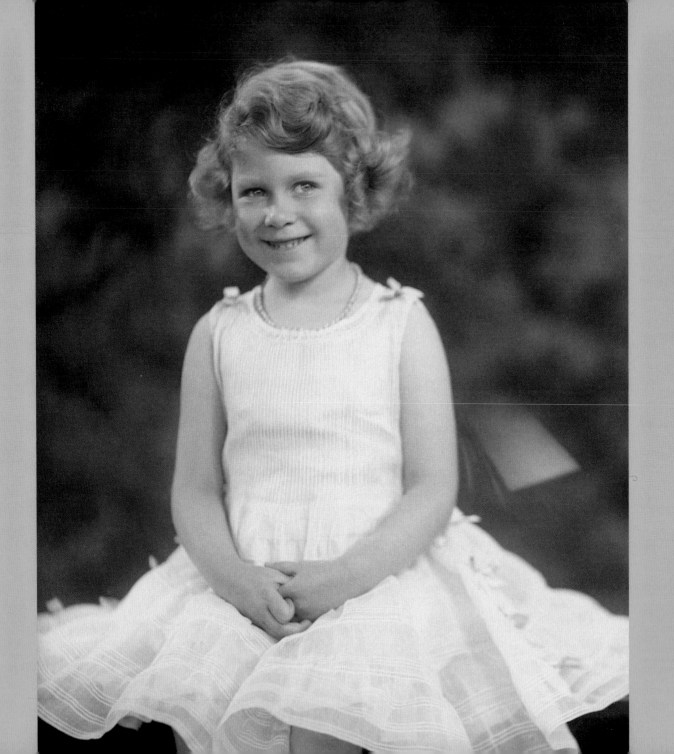

THE ROYAL SISTERS
1931–1935

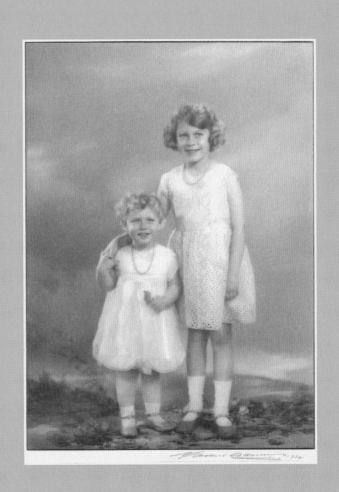

1931

Princess Elizabeth
in January 1931.

When talking about his work,
Adams said: 'The one
essential of a perfect picture
is simplicity. The delightful
simplicity of a child calls for
a simple pictorial statement.
The child should be the
dominant part of your
composition, and nothing
in the way of clutter and
furniture is necessary.'

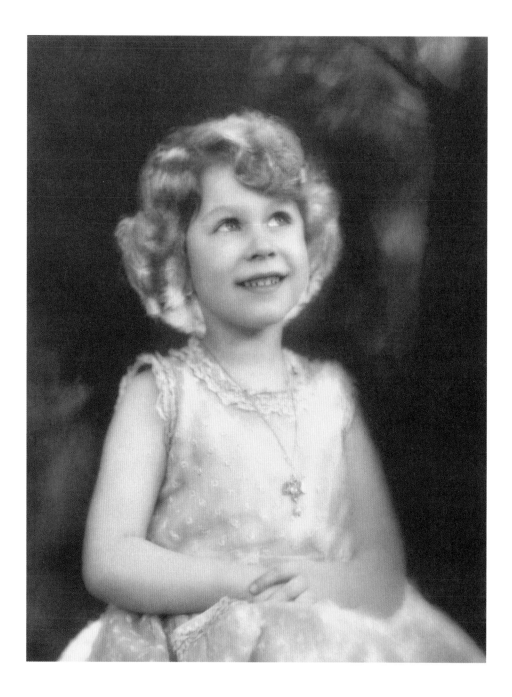

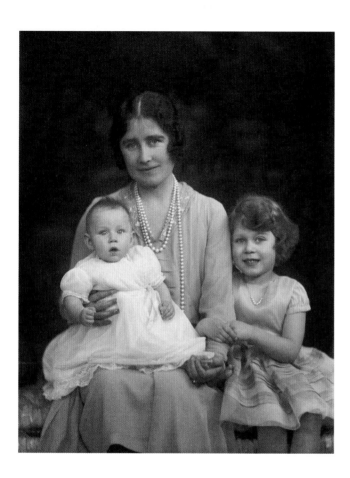

Princess Margaret was born at Glamis Castle on 21 August 1930, the second daughter of the Duke and Duchess of York. At the time of her birth she was fourth in line to the throne. The Princess was six months old when she was first photographed by Marcus Adams in February 1931, together with her mother and sister.

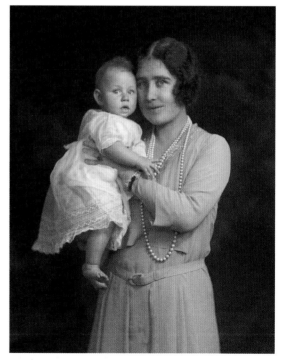

1931

Later that year, in June, the whole family visited Dover Street. Adams was intrigued by the unique relationship between parents and their children, and sought to capture their bonds of affection in his portraits.

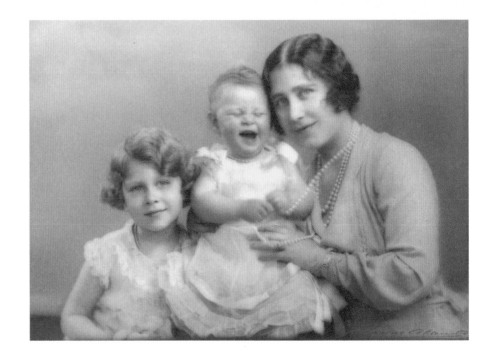

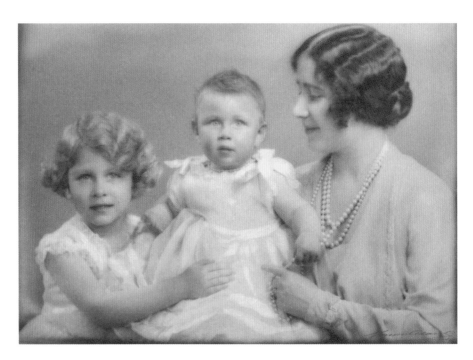

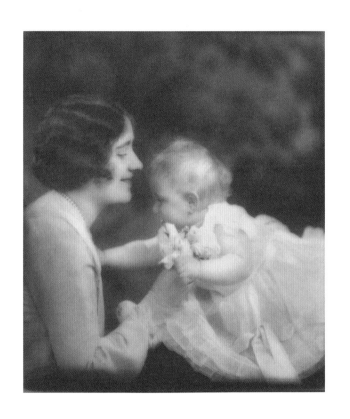

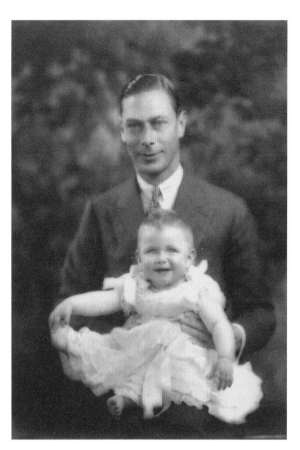

1931

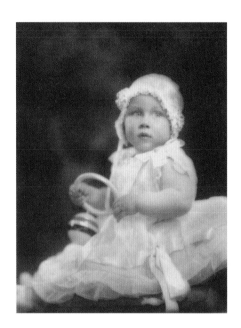
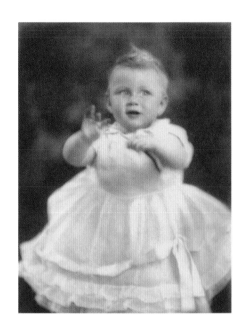
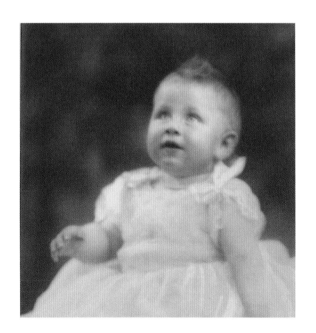
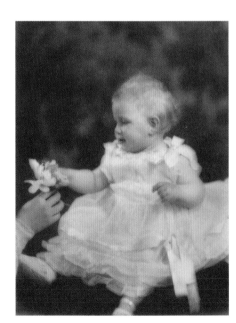

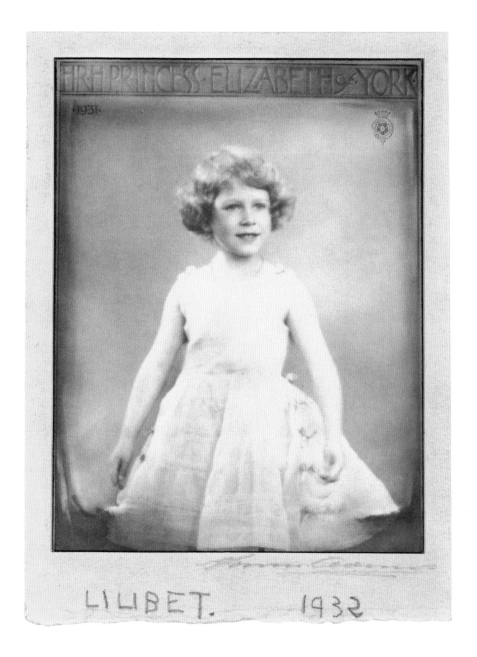

HRH PRINCESS ELIZABETH of YORK

·1931·

LILIBET. 1932

This portrait of Princess Elizabeth was one of many chosen to feature on cards that were produced for the Royal Family's private use. In this case 'HRH Princess Elizabeth of York', together with the year and the Princess's coroneted badge of the white rose of York, is included across the top of the image. The Princess signed it in 1932.

1932

There was only one royal sitting in 1932, but it resulted in a great many successful portraits.

Writing in *The Listener* in 1939, Adams explained that it is a child's ever-changing expression that he strove to capture: 'To realise these subtle and fleeting expressions one must be fit and in tune – your mind must be as sensitive as a photographic plate, and your actions as quick as a swallow.'

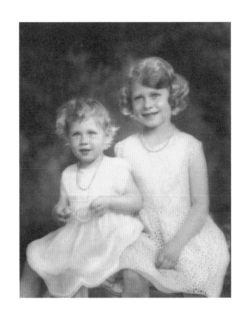

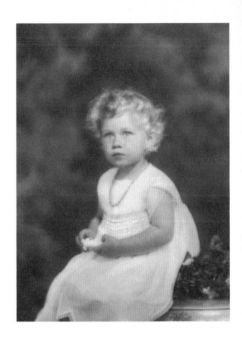

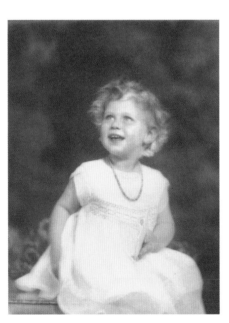

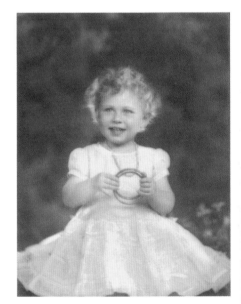

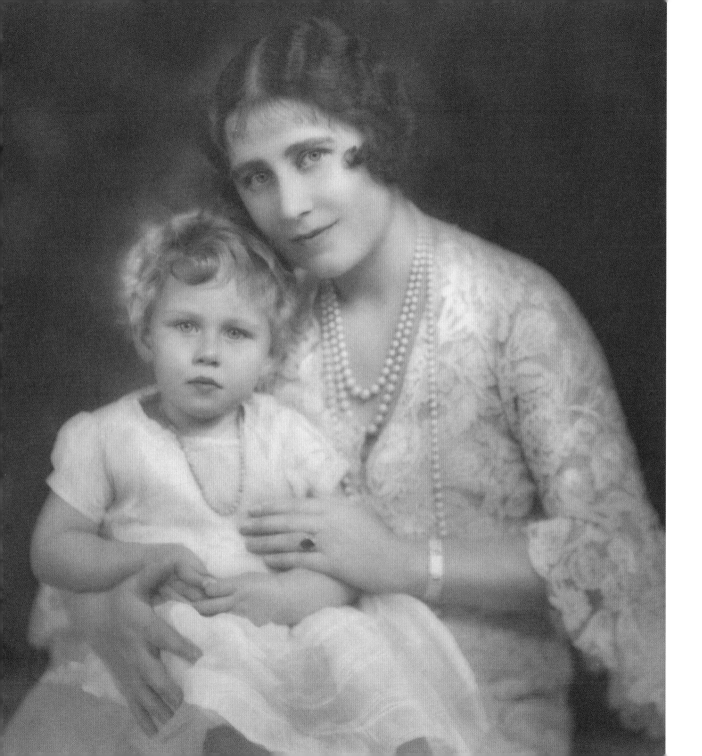

1932

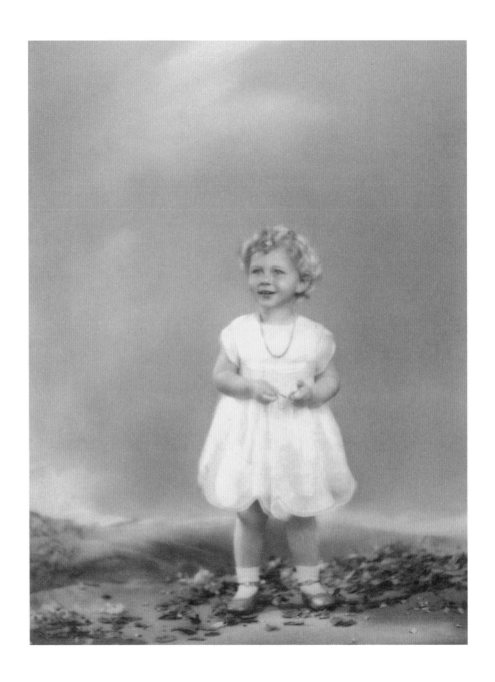

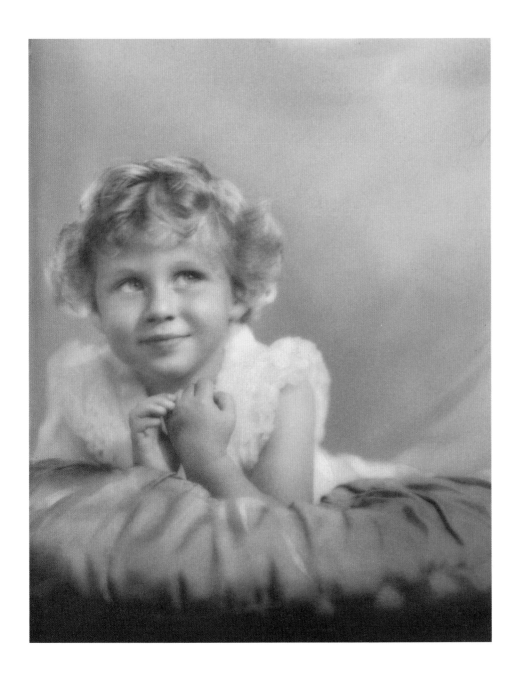

1933

Princess Margaret, photographed by Adams in a pose similar to that of Princess Elizabeth in her portrait of 1928 (see p. 39).

1933

Also from this sitting were two photographs that were subsequently coloured by Adams: the two Princesses standing together with the River Thames and Windsor Castle in the background, and Princess Margaret wearing a pink dress.

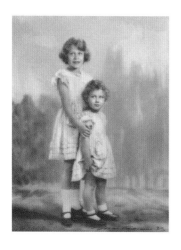

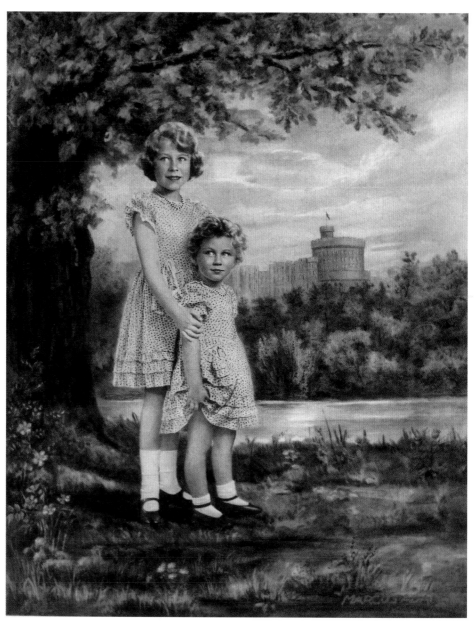

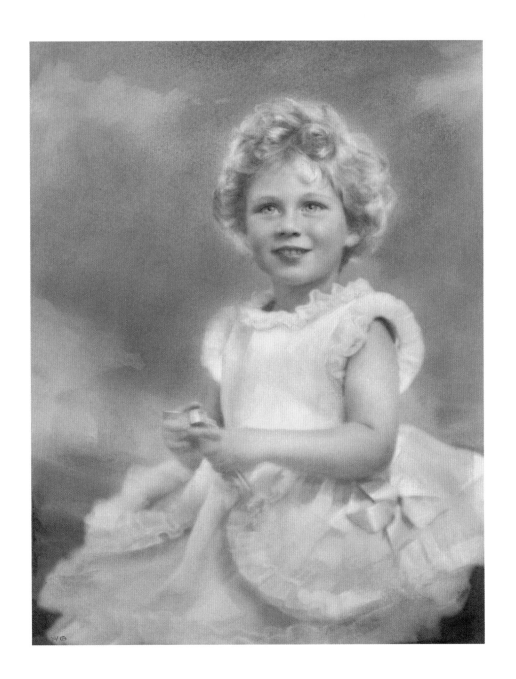

1934

This portrait of the eight-year-old Princess Elizabeth was taken in November 1934. She looks straight at the camera, displaying a poise beyond her years.

The photographs of Princesses Elizabeth and Margaret, both together and with their mother, were taken a week later.

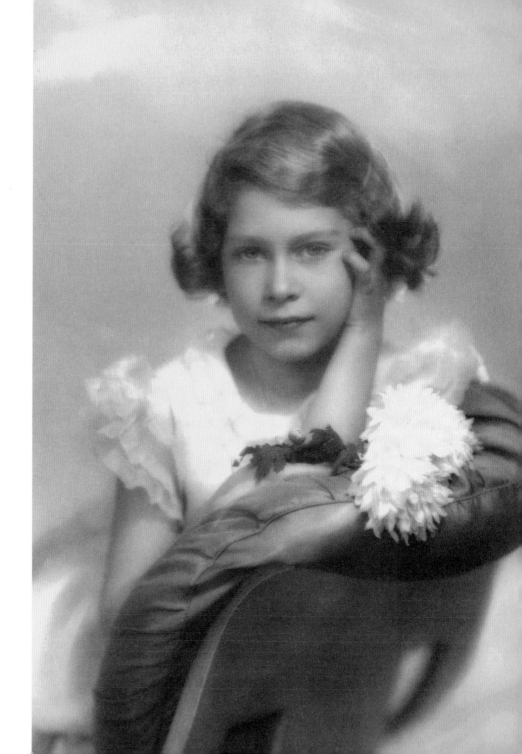

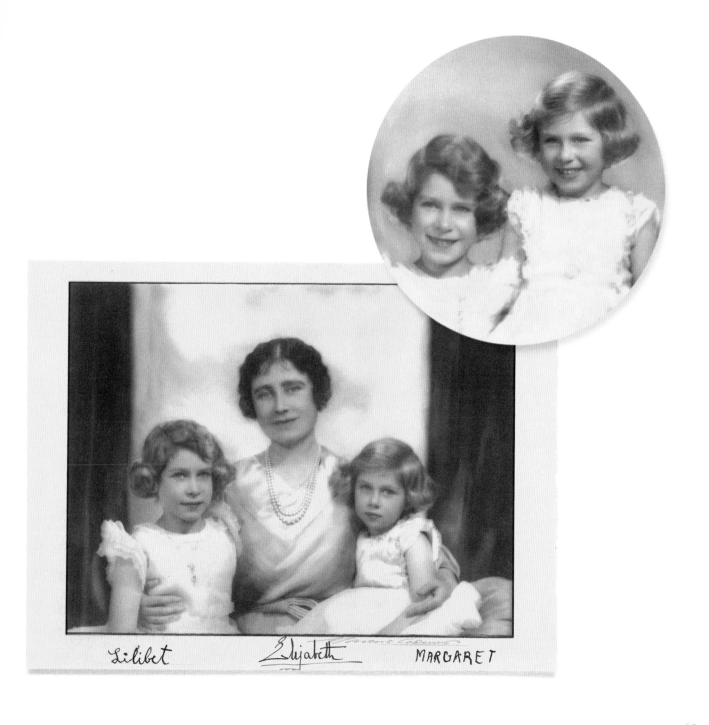

Lilibet Elizabeth MARGARET

1935

During the Princesses' visit to The Children's Studio in December 1935, they were photographed with two dolls evidently worthy of their own portrait. Princesses Elizabeth and Margaret wore matching dresses, trimmed with small flowers and delicate frills.

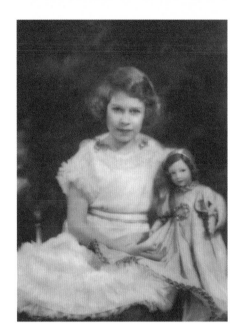

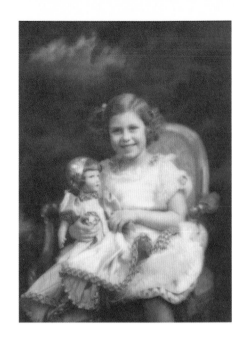

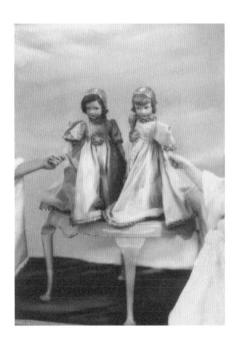

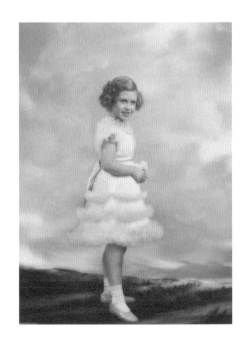

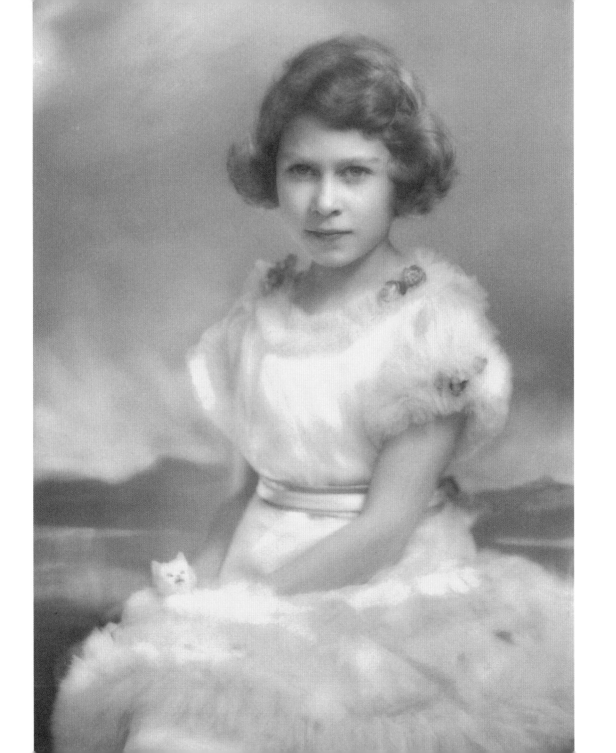

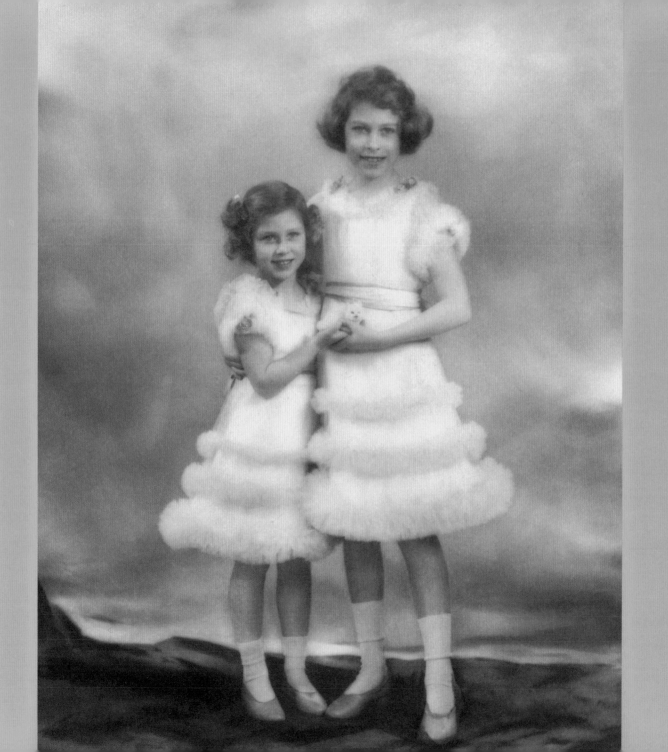

GROWING UP
1936–1941

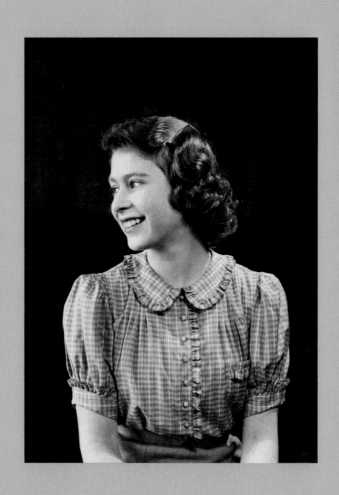

1936

On 20 January 1936
King George V died at
Sandringham and the Prince
of Wales acceded to the throne
as King Edward VIII. He was
never crowned, abdicating
after a reign of only 325 days.

On 11 December the Duke
of York was proclaimed
sovereign, as King George VI.
Realising that there would be
a demand for photographs of
the new Royal Family, not just
at home but worldwide,
a sitting was booked with
Adams for four days after the
accession. After the upset and
uncertainty of the preceding
few months, Adams produced
a reassuring image of a close-
knit, dependable family – one
that would conscientiously
fulfil every duty, royal or
otherwise, that might be
demanded of them.

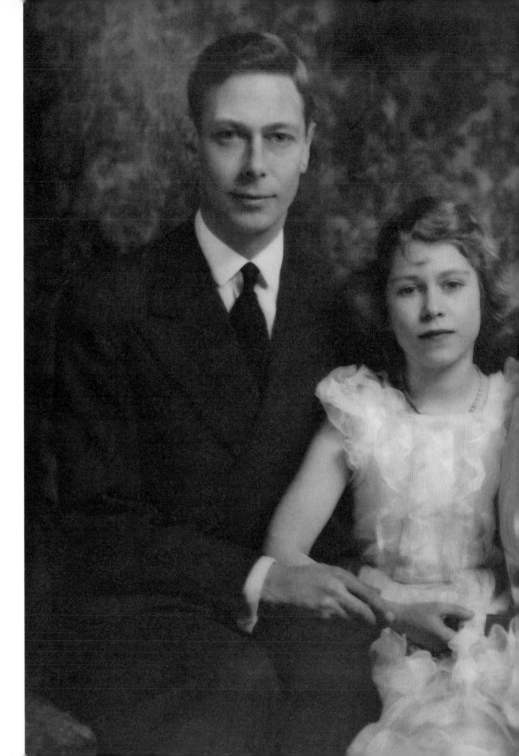

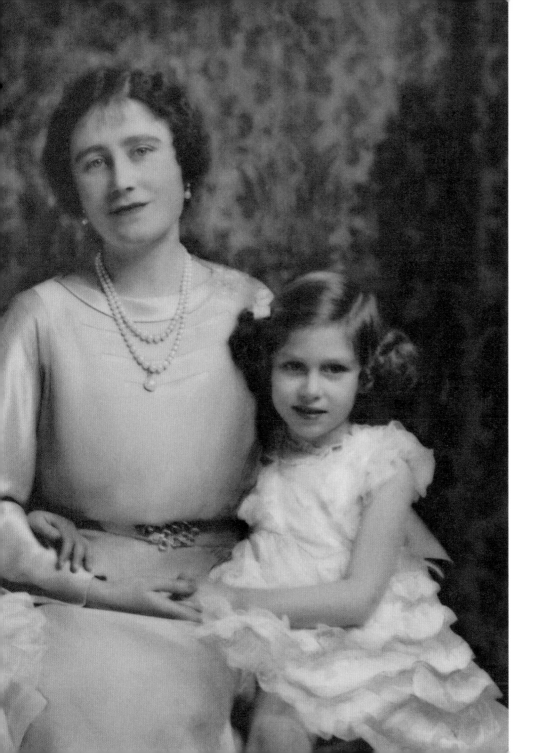

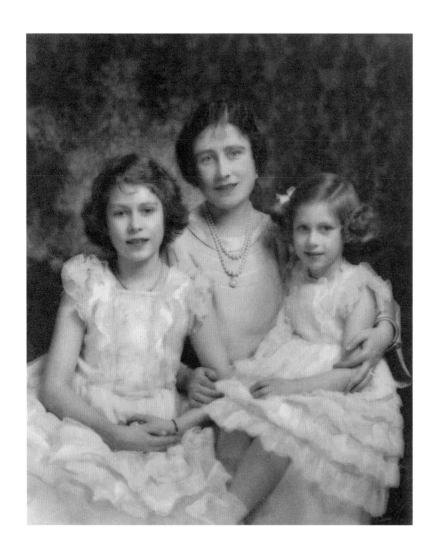

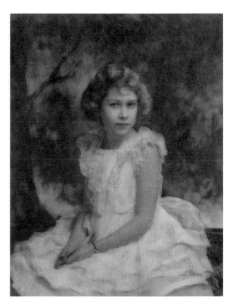

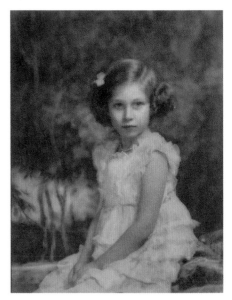

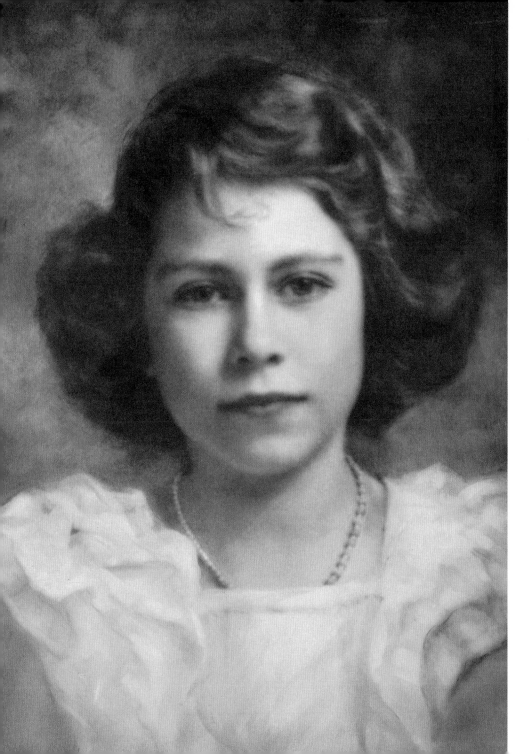

1936

As well as the group portrait of the whole family, Adams produced this striking head-and-shoulders view of Princess Elizabeth, now heir presumptive to the throne.

1938

In December 1938 Adams was asked to photograph the Royal Family at Buckingham Palace. This photograph posed certain technical problems for him. The large group had to be taken with a very wide aperture; this put the chandeliers in the background out of focus. He therefore took a second photograph of the background alone, from exactly the same position. The background in the first negative was bleached out, then the two negatives were bound together and the image was printed from this double negative. It was worth the effort; reproductions of this image ran into millions. Dookie, standing beside Princess Elizabeth, had been coaxed into position using a biscuit placed on the King's shoe.

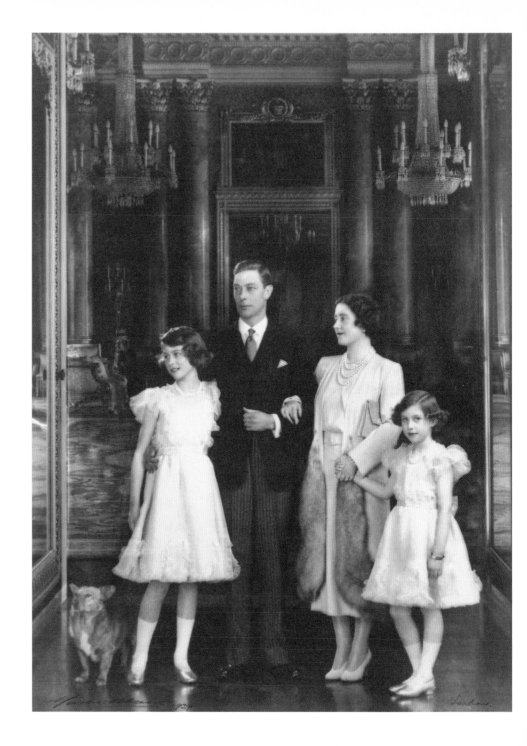

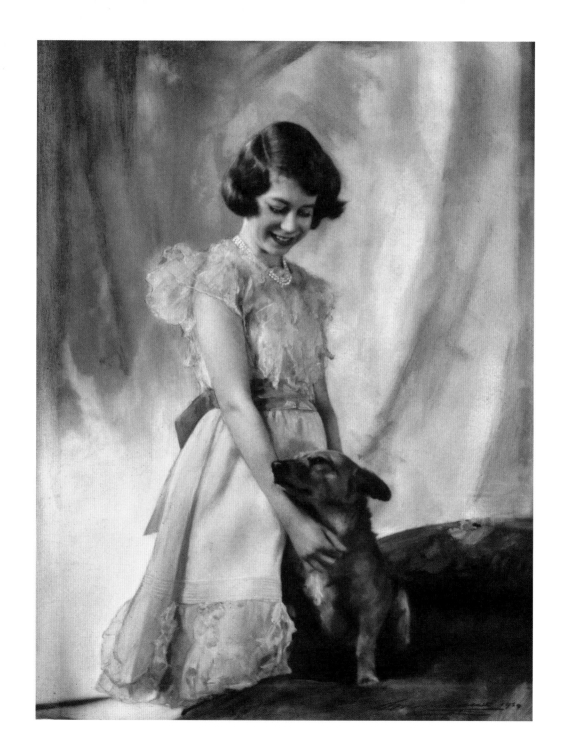

1939

The sitting in February 1939 was to be the last before the outbreak of the Second World War in September of that year, and the last of the Princesses wearing frilly dresses and pretty necklaces.

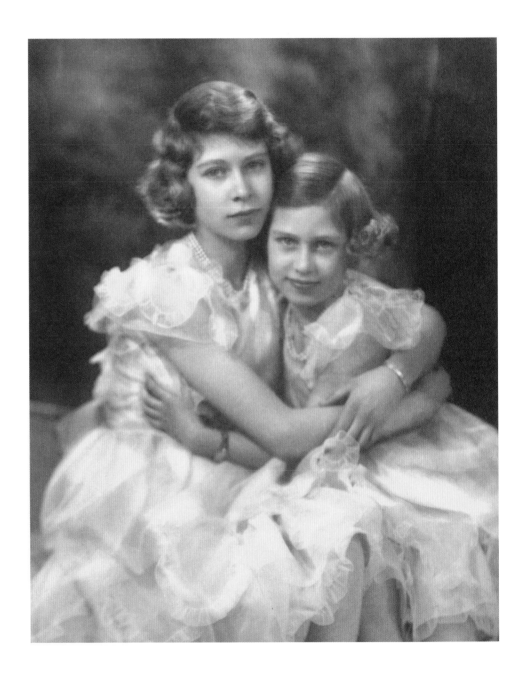

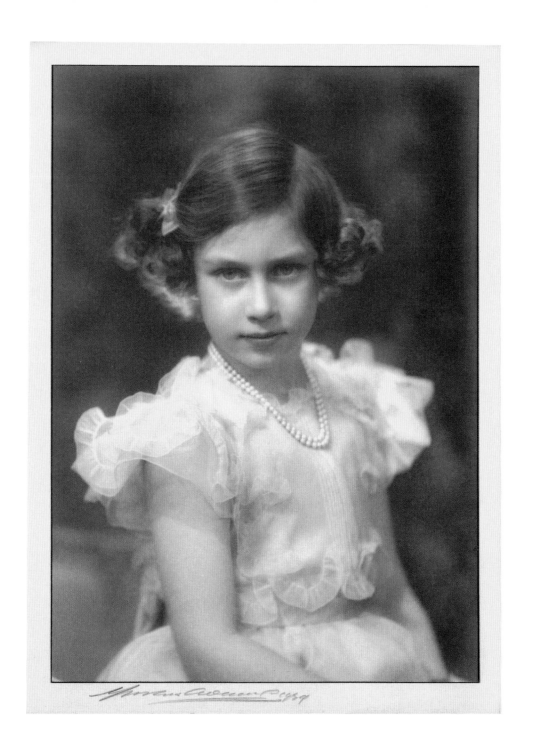

1940

Adams's photographs of the Princesses in the early 1940s show them wearing kilts and tweed jackets, simple and practical clothes appropriate for this period of national adversity.

The left-hand portrait, opposite, features another good example of Adams's backgrounds. He would work directly on the negative plate, enhancing the backdrop and adding interest to the foreground with a graphite pencil.

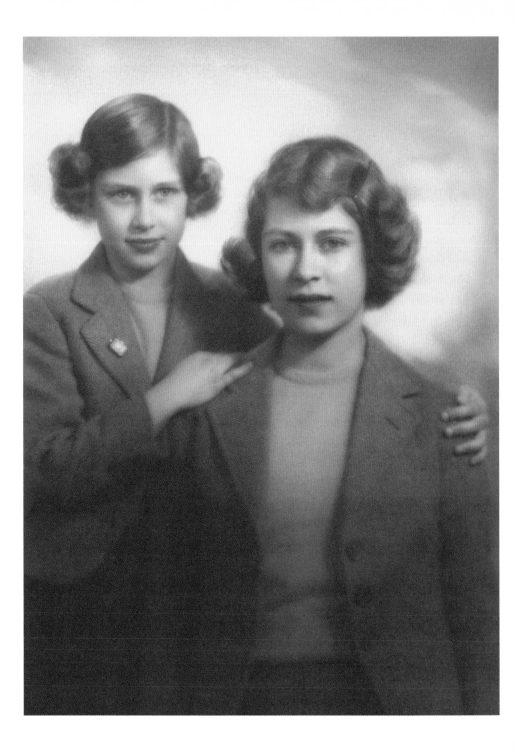

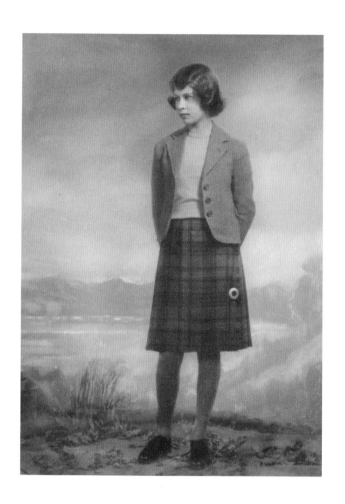

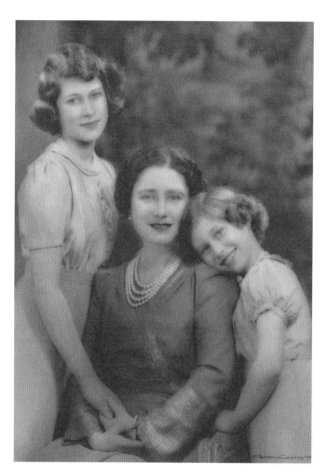

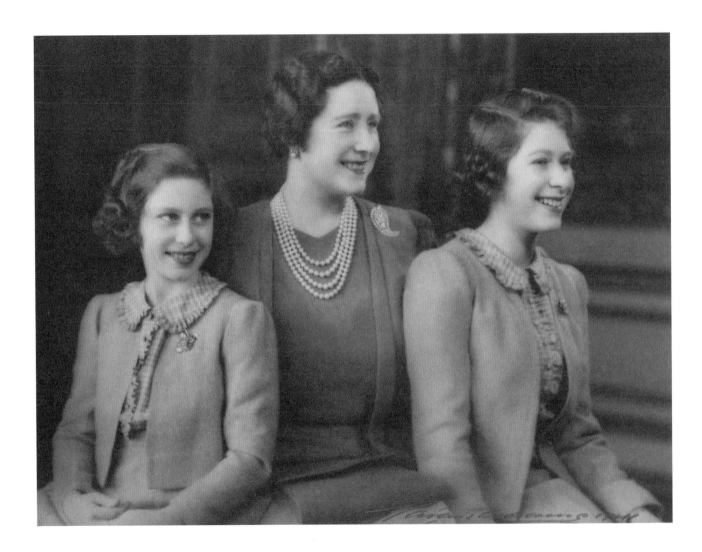

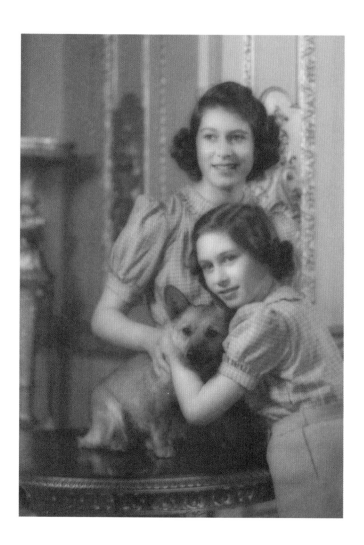

Adams's last sitting with Princesses Elizabeth and Margaret was in March 1941, at Windsor Castle. He photographed them with their mother, with Dookie, and also showed the Princesses working on a jigsaw puzzle.

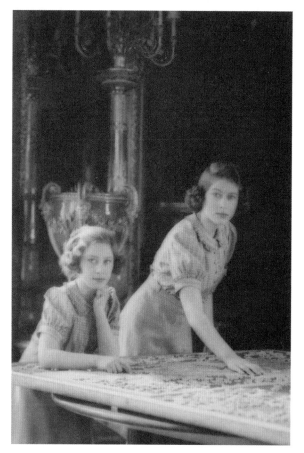

A NEW GENERATION
1949–1956

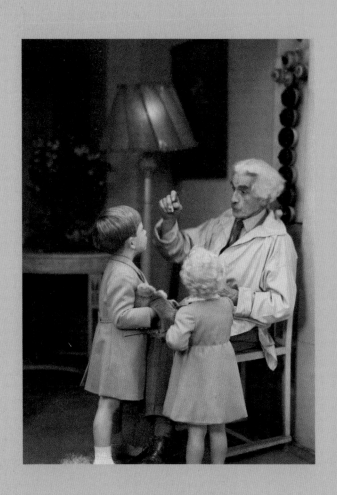

1949

In 1947 Princess Elizabeth married Prince Philip, Duke of Edinburgh. After the birth of their son Prince Charles in November 1948 there were more royal commissions for Marcus Adams. Between them, Prince Charles and Princess Anne (born in August 1950) were photographed by Adams thirteen times from 1949 to 1956, usually in July or October in order to produce birthday portraits.

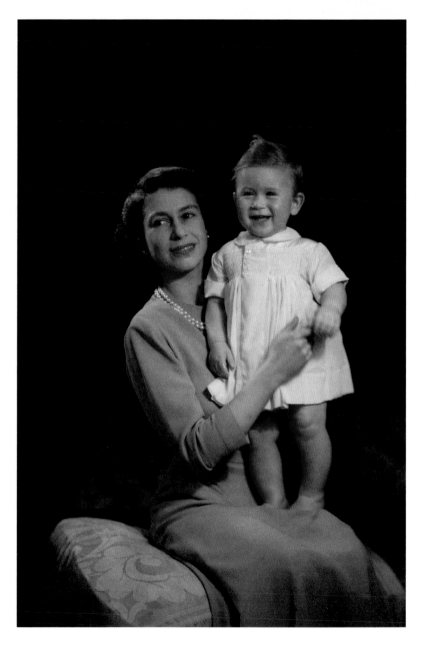

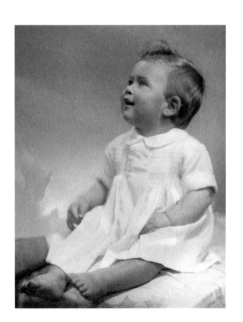

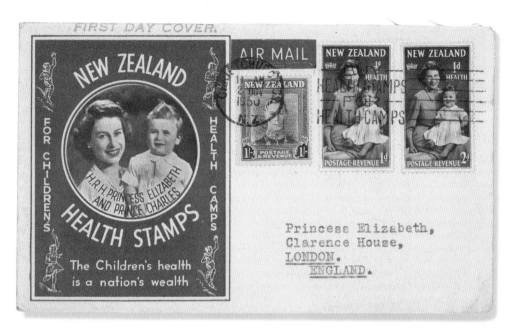

The portraits of Prince Charles on the left-hand page were taken during his first sitting with Adams in October 1949. Images from that session were selected for New Zealand's Health Stamps for 1950. Health Stamps have been issued annually since 1929 to raise funds for New Zealand's Health Camps for children.

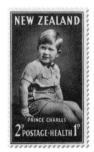

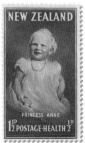

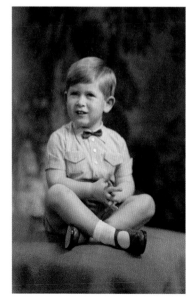

1951

New Zealand's Health Stamps issued in 1952 featured portraits of Prince Charles and Princess Anne taken by Marcus Adams in 1951.

1952

This photograph of Princess Anne was taken a month before her second birthday, at her first solo sitting with Adams. A few months later, in October 1952, Prince Charles and Princess Anne visited The Children's Studio together. Several of the successful images from this sitting (right) were published as post cards by Raphael Tuck & Sons Ltd.

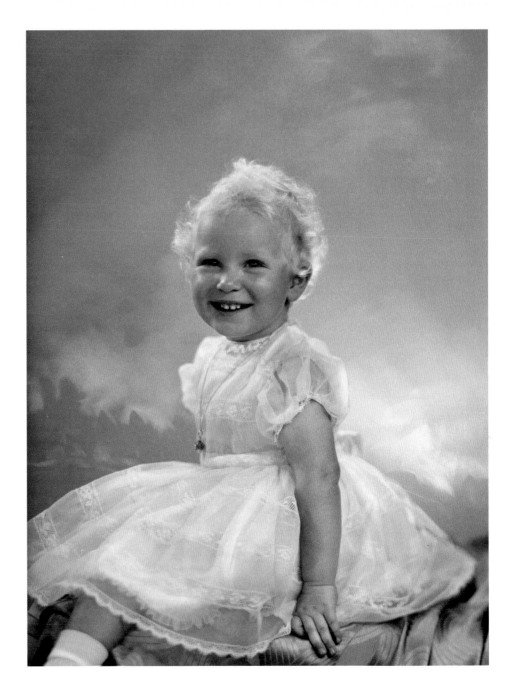

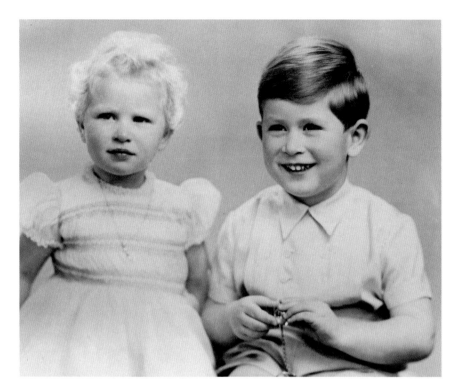

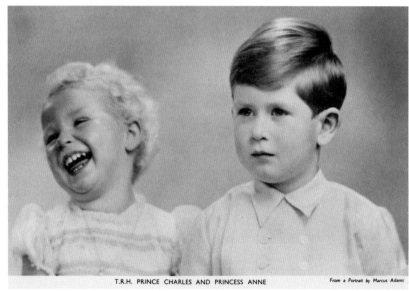

T.R.H. PRINCE CHARLES AND PRINCESS ANNE

From a Portrait by Marcus Adams

1953

In November 1953 The Queen and the Duke of Edinburgh left for the Commonwealth tour which they had abandoned in Kenya the year before, owing to the death of King George VI. A few days before their departure, Prince Charles attended a sitting with Adams, several pictures from which were published to mark the young Prince's fifth birthday.

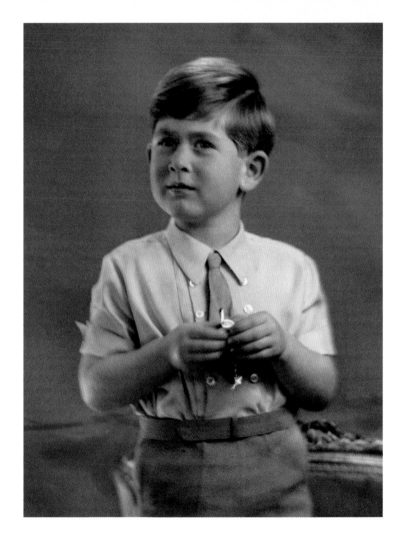

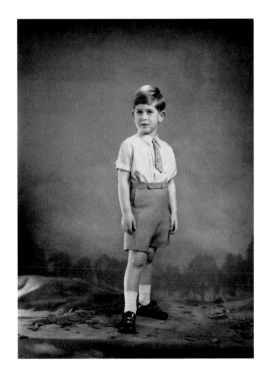

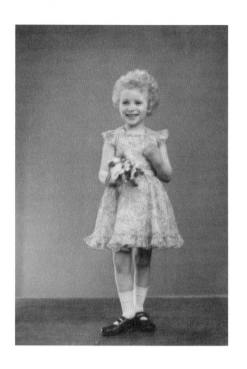

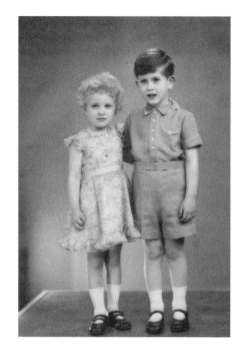

1954

Prince Charles and Princess Anne sat for Adams twice during their parents' absence, in February and April of 1954. The photographs from these sittings were sent out to The Queen and the Duke, just as photographs of Princess Elizabeth had been sent to the Duke and Duchess of York during their tour of Australia and New Zealand in 1927. The measuring stick was to show how fast the children were growing.

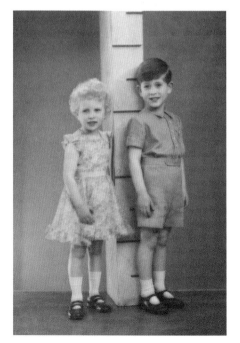

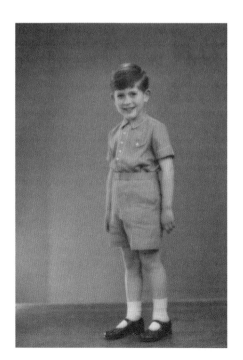

1954

This photograph of Princess Anne was taken in July 1954 to mark her fourth birthday. A few months later, in November, The Queen accompanied her children to Adams's studio, where all three were photographed together.

1956

Overleaf (p. 90): This is one of a series of portraits of Princess Anne taken in July 1956, Adams's last royal sitting. The photographs were released to mark the Princess's sixth birthday.

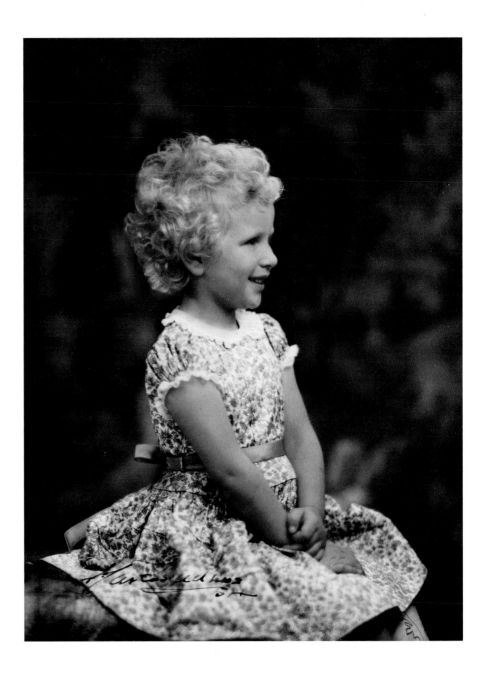

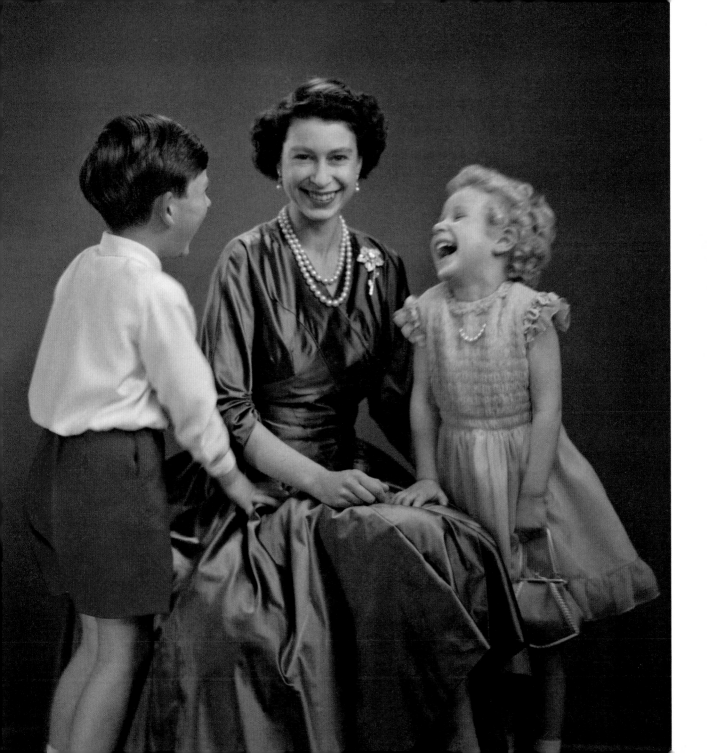

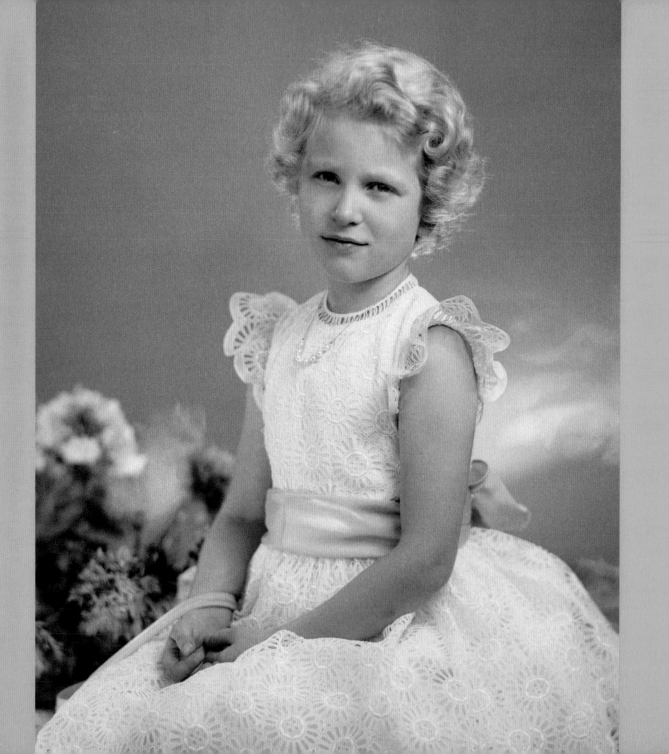

ROYAL RELATIVES

1922

The Infantas Beatriz (below) and Maria Cristina (right), born in 1909 and 1911 respectively, were the daughters of King Alfonso XIII and Queen Victoria Eugenia of Spain. Their maternal grandmother was Princess Beatrice, Queen Victoria's youngest child.

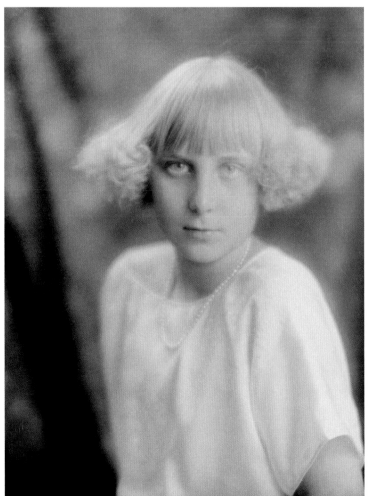

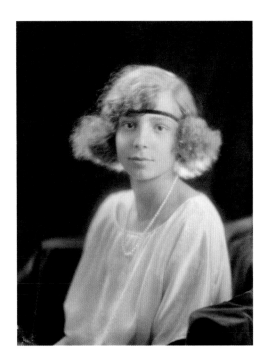

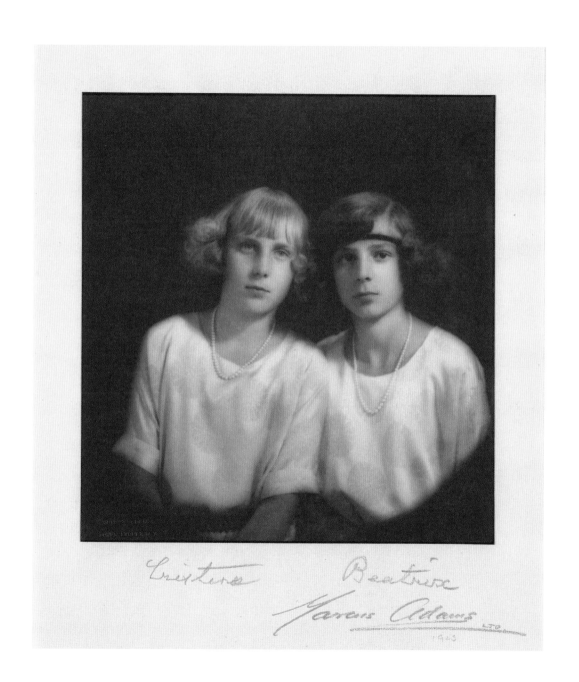

Cristina *Beatrix*

Marcus Adams

1945

1924

Timothy and Nancy Bowes Lyon were twins, born on 18 March 1918. Their father Patrick, Lord Glamis, was the eldest brother of Queen Elizabeth. In 1944 he succeeded as 15th Earl of Strathmore and Kinghorne. The twins were photographed by Adams individually and with their mother, Lady Glamis, in 1924. Timothy succeeded his father as 16th Earl of Strathmore and Kinghorne in 1949.

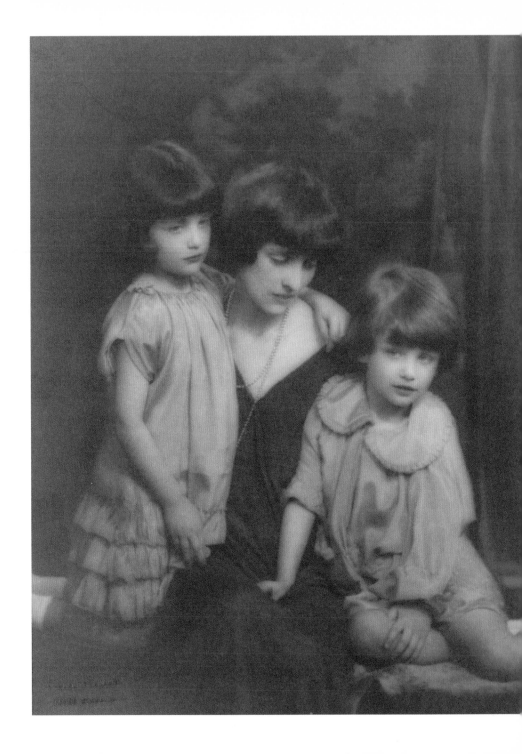

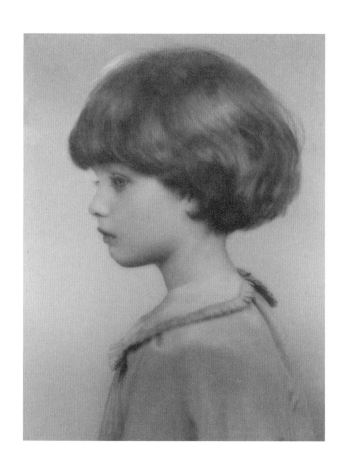
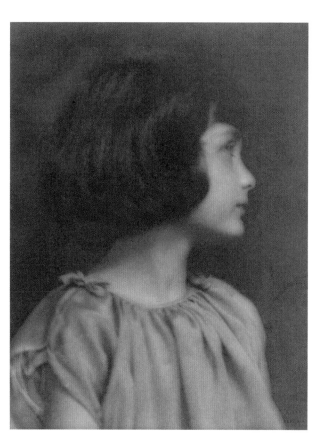

1934

Prince Nikola was the younger
son of Prince Paul of
Yugoslavia and his wife,
Princess Olga of Greece and
Denmark. This photograph
was taken in November 1934,
when he was six years old.
He is shown below with his
mother, who was the eldest
sister of Princess Marina,
Duchess of Kent (opposite).

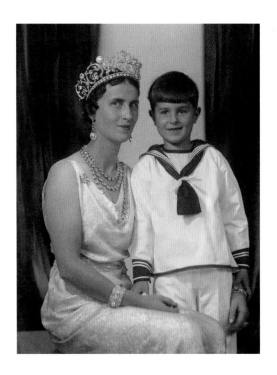

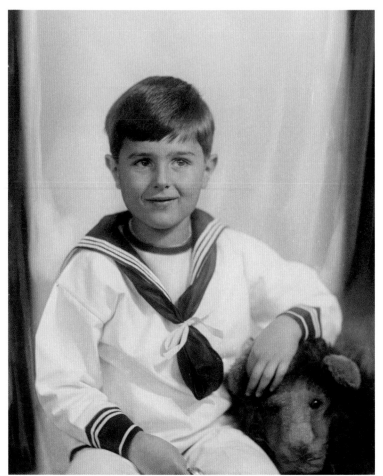

1936

Prince Edward, now the Duke of Kent, was born in October 1935. He is the elder son of Prince George, Duke of Kent, and Princess Marina, Duchess of Kent. He was four months old when he was first photographed with his mother by Adams. A few months later, just before his first birthday, the young Prince was photographed with both of his parents (overleaf).

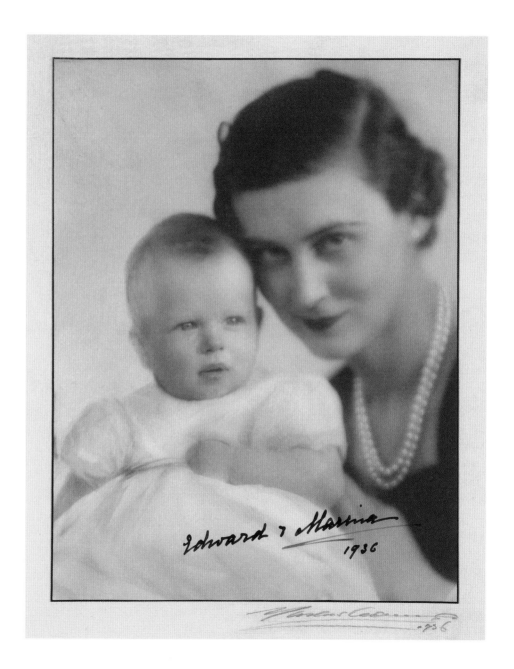

Edward & Marina
1936

1936

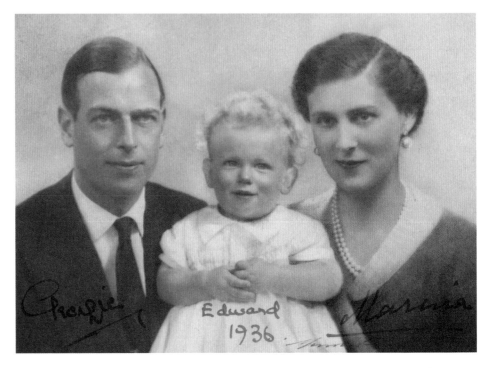

1937

Princess Alexandra, the Duke and Duchess of Kent's second child and only daughter, was born on Christmas Day 1936. These portraits are from a sitting in June 1937; the photographs of the two children were inscribed by their mother, Princess Marina.

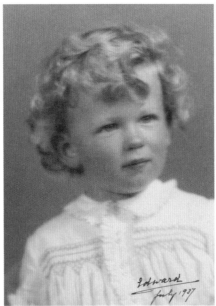

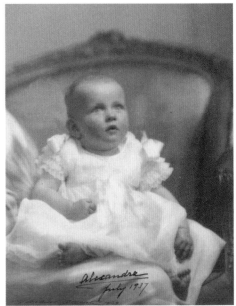

1943

These two portraits of Prince
William of Gloucester were
taken in October 1943, when
he attended The Children's
Studio with his father,
Henry, Duke of Gloucester.

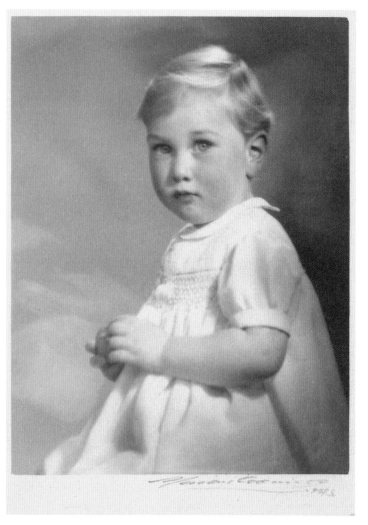

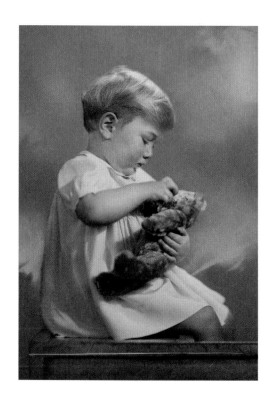

ROYAL PORTRAITS
BY BERTRAM PARK

1922

This portrait (and that on the previous page) of Lady Elizabeth Bowes Lyon was taken in January 1922, the year before her engagement and marriage to the Duke of York.

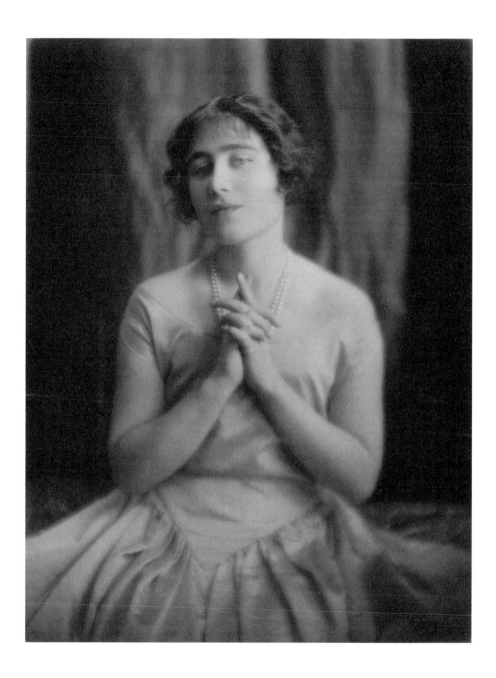

1929

The Duchess of York, July 1929. Bertram Park has given this photograph a different treatment, enhancing the image with crayon and stumping chalk.

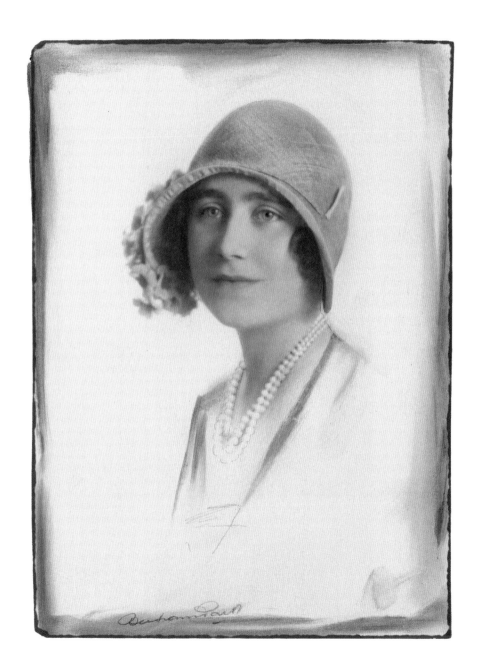

1936

Both King George VI and Queen Elizabeth were photographed by Bertram Park after the accession in 1936, on the same occasion as the visit of the Royal Family to The Children's Studio (pp. 68–9).

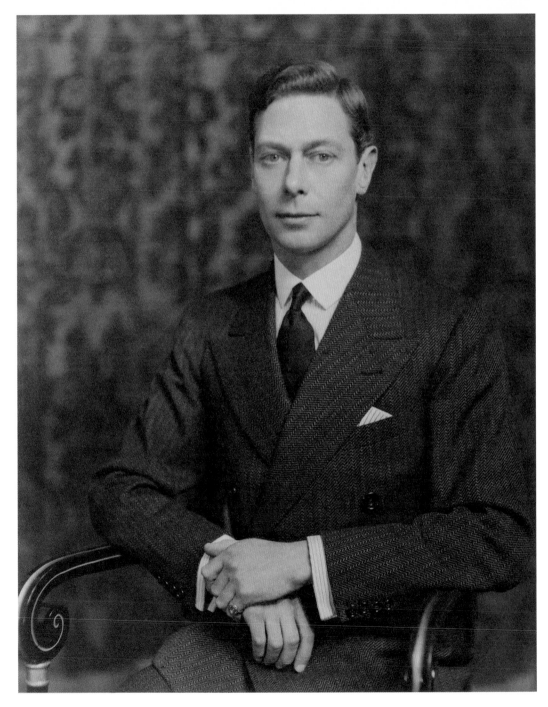

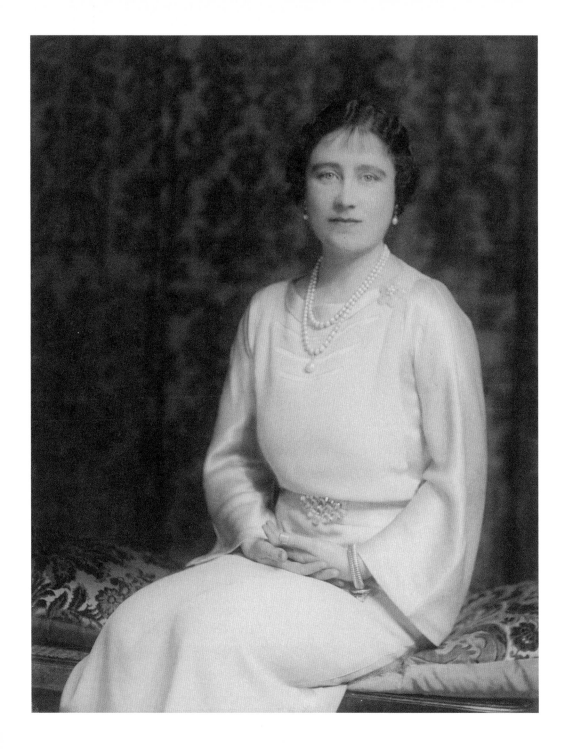

1919

Princess Victoria Eugénie was the only daughter of Prince Henry of Battenberg and Princess Beatrice, the youngest child of Queen Victoria and Prince Albert. In 1906 she married King Alfonso XIII of Spain and became Queen Victoria Eugenia. This photograph was taken in November 1919. Her daughters – the Infantas Beatriz and Maria Cristina – were photographed by Marcus Adams three years later (pp. 92–3).

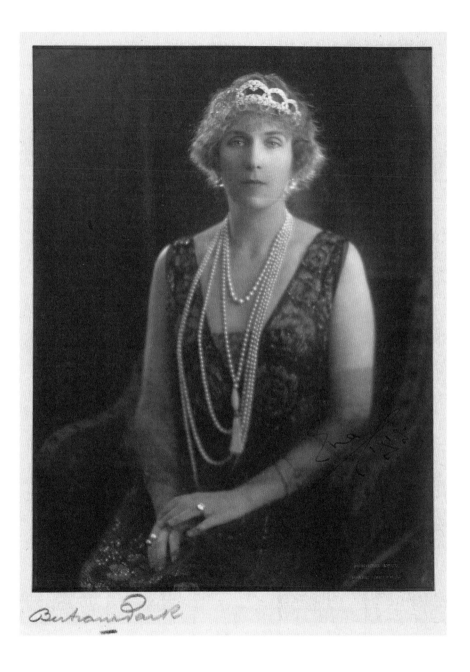

1934

Princess Olga of Greece and Denmark was born in Athens in June 1903. In 1923 she married Prince Paul of Yugoslavia, who became Regent after the assassination of King Alexander I of Yugoslavia on 9 October 1934. This portrait of the Princess was taken in November 1934, when she was in London to attend her sister Marina's marriage to George, Duke of Kent. She was photographed by Marcus Adams with her son Nikola at the same time (p. 96).

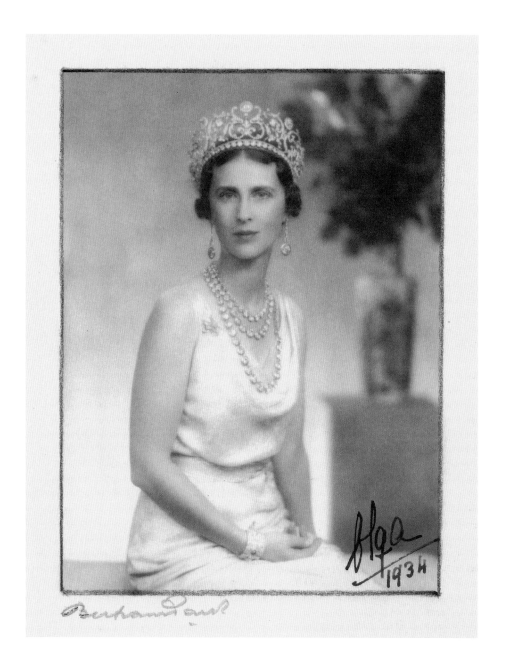

THE MARCUS ADAMS COLLECTION

Following two acquisitions, by gift via Mr John Bone in 2003, and by purchase from Mrs Rosalind Adams in 2006, the Royal Collection now holds all known extant Adams negatives from portraiture sittings with members of the Royal Family, more than 2,400 negatives in total. The Royal Collection also holds more than 600 vintage silver gelatin prints by Marcus Adams, acquired principally by King George VI and Queen Elizabeth; two albums of reference prints compiled by the photographer; and three negative books listing the sittings.

MARCUS ADAMS'S ROYAL SITTINGS

1926 **2 December**
The Duke and Duchess of York
with Princess Elizabeth

1927 **20 January**
Princess Elizabeth

3 March
Princess Elizabeth

31 March
Queen Mary with
Princess Elizabeth

6 May
Princess Elizabeth

30 June
The Duke and Duchess of York
with Princess Elizabeth

1928 **5 July**
The Duchess of York with
Princess Elizabeth

1929 **30 July**
The Duke and Duchess of York
with Princess Elizabeth

14 November
Princess Elizabeth

1931 **22 January**
Princess Elizabeth

2 February
The Duchess of York with
Princesses Elizabeth
and Margaret

22 June
The Duke and Duchess of York
with Princesses Elizabeth
and Margaret

21 July
Princess Elizabeth

1932 **15 July**
The Duchess of York with
Princesses Elizabeth
and Margaret

1933 **12 July**
The Duke and Duchess of York
with Princesses Elizabeth
and Margaret

1934 **1 November**
Princess Elizabeth

7 November
The Duke and Duchess of York
with Princesses Elizabeth
and Margaret

1935 **13 December**
Princesses Elizabeth and
Margaret

1936 **17 February**
The Duchess of Kent with
Prince Edward

7 October
The Duke and Duchess of Kent
with Prince Edward

15 December
King George VI, Queen
Elizabeth and Princesses
Elizabeth and Margaret

1937 **21 June**
The Duchess of Kent, Prince
Edward and Princess Alexandra

1938 **20 December**
King George VI, Queen
Elizabeth and Princesses
Elizabeth and Margaret

1939 **16 February**
Princesses Elizabeth
and Margaret

1940 **9 April**
Queen Elizabeth with Princesses
Elizabeth and Margaret

10 April
Prince Edward and
Princess Alexandra of Kent

1941 **18 March**
Queen Elizabeth with Princesses
Elizabeth and Margaret

1943 **27 October**
The Duke of Gloucester with
Prince William

1949 **26 October**
Princess Elizabeth with
Prince Charles

1951 **26 July**
Princess Elizabeth, Prince
Charles and Princess Anne

29 October
Prince Charles

1952 **15 July**
Princess Anne

24 October
Prince Charles and
Princess Anne

1953 **23 July**
Prince Charles and
Princess Anne

29 October
Prince Charles

1954 **23 February**
Prince Charles and
Princess Anne

12 April
Prince Charles and
Princess Anne

20 July
Princess Anne

6 November
The Queen, Prince Charles
and Princess Anne

1955 **19 July**
Princess Anne

1956 **20 July**
Princess Anne

ROYAL FAMILY TREE

This Royal Family tree shows only
those members of the family
mentioned in the text.

Queen Victoria = Prince Albert
(1819–1901) | of Saxe-Coburg and Gotha
(1819–61)

King Edward VII = Princess Alexandra
(1841–1910) | of Denmark
(1844–1925)

Prince Arthur,
Duke of Connaught
(1850–1942)

Claude, Earl of = Nina
Strathmore and Kinghorne | Cavendish-Bentinck
(1855–1944) | (1862–1938)

King George V = Princess Victoria Mary
(1865–1936) | of Teck
(1867–1953)

Patrick, Earl of = Lady Dorothy Osborne
Strathmore and Kinghorne | (1888–1946)
(1884–1949)

Lady Elizabeth Bowes Lyon = King George VI
(1900–2002) | (1895–1952)

King Edward VIII
(1894–1972)

The Hon. Timothy Bowes Lyon (1918–72)
The Hon. Nancy Bowes Lyon (1918–59)

Queen Elizabeth II = Prince Philip,
(b. 1926) | Duke of Edinburgh
(b. 1921)

Princess Margaret = Antony Armstrong Jones,
(1930–2002) | Earl of Snowdon
(b. 1930)

Charles, Prince of Wales (b. 1948)
Anne, Princess Royal (b. 1950)
Prince Andrew, Duke of York (b. 1960)
Prince Edward, Earl of Wessex (b. 1964)

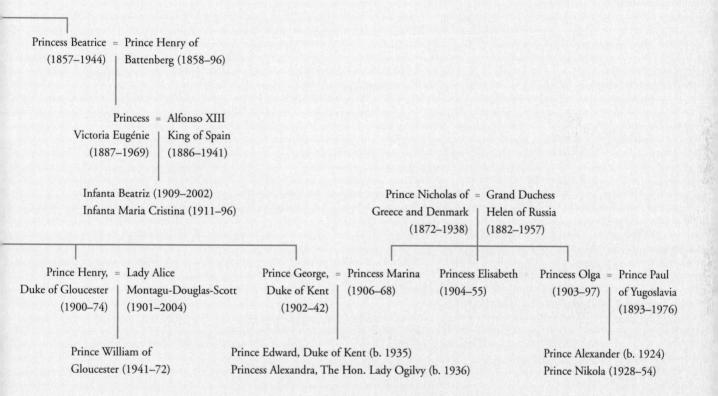

Princess Beatrice = Prince Henry of
(1857–1944) | Battenberg (1858–96)

Princess = Alfonso XIII
Victoria Eugénie | King of Spain
(1887–1969) | (1886–1941)

Infanta Beatriz (1909–2002)
Infanta Maria Cristina (1911–96)

Prince Nicholas of = Grand Duchess
Greece and Denmark | Helen of Russia
(1872–1938) | (1882–1957)

Prince Henry, = Lady Alice
Duke of Gloucester | Montagu-Douglas-Scott
(1900–74) | (1901–2004)

Prince George, = Princess Marina
Duke of Kent | (1906–68)
(1902–42)

Princess Elisabeth
(1904–55)

Princess Olga = Prince Paul
(1903–97) | of Yugoslavia
| (1893–1976)

Prince William of
Gloucester (1941–72)

Prince Edward, Duke of Kent (b. 1935)
Princess Alexandra, The Hon. Lady Ogilvy (b. 1936)

Prince Alexander (b. 1924)
Prince Nikola (1928–54)

MARCUS ADAMS'S
FAMILY TREE

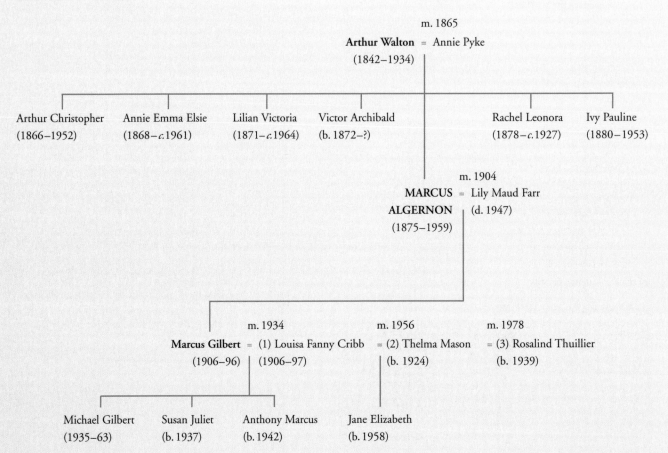

m. 1865

Arthur Walton = Annie Pyke
(1842–1934)

Arthur Christopher Annie Emma Elsie Lilian Victoria Victor Archibald Rachel Leonora Ivy Pauline
(1866–1952) (1868–*c*.1961) (1871–*c*.1964) (b. 1872–?) (1878–*c*.1927) (1880–1953)

m. 1904

MARCUS = Lily Maud Farr
ALGERNON (d. 1947)
(1875–1959)

m. 1934 m. 1956 m. 1978

Marcus Gilbert = (1) Louisa Fanny Cribb = (2) Thelma Mason = (3) Rosalind Thuillier
(1906–96) (1906–97) (b. 1924) (b. 1939)

Michael Gilbert Susan Juliet Anthony Marcus Jane Elizabeth
(1935–63) (b. 1937) (b. 1942) (b. 1958)

ACKNOWLEDGEMENTS

The permission of HM The Queen
to reproduce items in the Royal Collection and
the Royal Archives is gratefully acknowledged.

The support of a number of colleagues in the
Royal Household is much appreciated.

The assistance of the following people and
institutions is gratefully acknowledged:

Rosalind Adams
Altaimage, London
John Bone
Peter Drew, Phrogg Design
Jenny Knight, copy editor
Printer Trento, Italy
Vicki Robinson, indexer
Alison Thomas, proof reader
Debbie Wayment, production manager
Matthew Williams, Reading Museum
Philippa Wright, National Media Museum
Susan Yonker

Marcus Adams's box in which
he kept a variety of materials
and tools for retouching negatives
and prints, including assorted
tortillons, graphite pencils
and phials of stumping chalk.

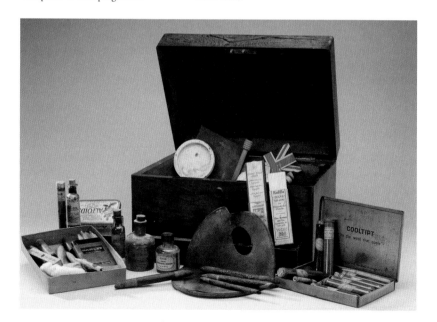

LIST OF SOURCES

Material in the Adams Archive is quoted with the
kind permission of Rosalind Adams.

Information in the text which is not directly
acknowledged comes from unpublished typescripts
and manuscripts in the Adams Archive.

Quotations on the following pages are from the
Adams Archive: pp. 7, 11, 12, 13, 17, 18 (second
quotation), 24, 26, 27 (first quotation).

pp. 6, 13, 15-16, 50, 56
Quotations from Marcus Adams, 'I Photograph
Children' in *The Listener*, 9 February 1939

p. 8
Marcus Adams quoted in *Marcus Adams,
Photographer Royal* by Rosalind Thuillier,
Aurum Press, 1985

p. 9
The London Salon of Photography Website,
http://www.londonsalon.org (20 October 2009)

p. 13
Tony Armstrong Jones (Earl of Snowdon),
London, Weidenfeld & Nicolson, 1958

p. 18 (first quotation)
Marcus Adams, *The Rhythm of Children's Features*,
Pitman & Sons Ltd, 1935

pp. 19, 27 (second quotation)
Cited in 'Old Master of Young Faces' by Allen
Andrews in *Illustrated*, 12 September 1953

pp. 22-23
Extract from Sylvia Bennett's diary, Adams Archive

pp. 24-25
Letter from Marcus Adams to Gilbert Adams,
23 July 1953, Adams Archive

p. 32
Extract from the Duchess of York's diary
(RA QEQM/PRIV/DIARY: 6 January 1927),
The Royal Archives © 2010, HM Queen
Elizabeth II.

LIST OF ILLUSTRATIONS

Unless otherwise stated all photographs are by Marcus Adams and all illustrations are The Royal Collection © 2010 HM Queen Elizabeth II.

All photographs that are '© The Estate of Marcus Adams' are reproduced with kind permission of Rosalind Adams.

Royal Collection Enterprises are grateful for permission to reproduce the following images. Every effort has been made to contact copyright holders; any omissions are inadvertent, and will be corrected in future editions if notification of the amended credit is sent to the publisher in writing.

Unless otherwise stated, dates given refer to the sitting at which the original photograph was taken.

LIFE AND WORK

Pages 6 and 7

• Walton Adams, *Cabinet print (and verso) of General Gordon,* 1882, Adams & Stilliard Studio, Southampton; albumen print (RCIN 2912322): Reproduced by kind permission of Chris Franklin, Walton Adams Photographers.

• Photographer unknown, *Walton, Marcus and Gilbert Adams, c.*1908; toned gelatin silver print: © The Estate of Marcus Adams

• Marcus Adams for Walton Adams & Sons, Reading, *Sandringham Church, north side, c.*1915; half tone print; Charles Keyser, 'Notes on some Ancient Stained Glass in Sandringham Church, Norfolk' *Norfolk Archaeology: A Journal of Archaeology and Local History,* Volume 19, published by The Norfolk and Norwich Archaeological Society, 1917 (RCIN 2943809): © The Estate of Marcus Adams/Reproduced by kind permission of Chris Franklin, Walton Adams Photographers.

Pages 8 and 9

• *Young girl from Reading, c.*1912; gelatin silver print: photograph: Reading Museum Service (Reading Borough Council). All rights reserved: © The Estate of Marcus Adams

• *Barge on the River Thames opposite De Montfort Island in Reading, c.*1910; gelatin silver print: photograph: Reading Museum Service (Reading Borough Council). All rights reserved: © The Estate of Marcus Adams

• *Advertisement for The Children's Studio in Reading:* © The Estate of Marcus Adams

• *An example of Adams's phase photography, c.*1905; gelatin silver print: © The Estate of Marcus Adams

Pages 10 and 11

• *'Winding up my aeroplane', c.*1910; gelatin silver print: © The Estate of Marcus Adams

• *Photograms of the Year 1928* (RCIN 2943813); cover, frontispiece and title page showing Adams image of Princess Elizabeth; half tone print: © Reserved/The Royal Collection

Pages 12 and 13

• *Marcus Adams with Prince Charles,* 29 October 1953; reproduced from an original glass plate negative (RCIN 2141115)

• *Three logos for Marcus Adams's Children's Studio in London* (RCINs 2943748, 2943747, 2943582.v): © The Estate of Marcus Adams

Pages 14 and 15

• *Negative Book,* covering the years 1920-29 (RCIN 2943329)

• *Marcus Adams working with a young child,* series of three photographs, 1935; reproduced from original glass plate negatives (RCINs 2943763-5): © The Estate of Marcus Adams

Pages 16 and 17

• *Pencil sketches and watercolours of street scenes in Nazareth and Bethlehem,* 1904: © The Estate of Marcus Adams

• *Night Picture,* St Mark's Square, Venice, 1953; gelatin silver print: reproduced with kind permission of Susan Yonker: © The Estate of Marcus Adams

Pages 18 and 19

• *Pencil study of Princess Elizabeth's hands playing with an early Victorian crystal watch,* 1934: © The Estate of Marcus Adams

• Photographer unknown, *Marcus Adams's travelling camera, c.*1939; gelatin silver print: The Estate of Marcus Adams/© Reserved

• Photographer unknown, *Marcus Adams with his travelling camera, c.*1939; gelatin silver print: The Estate of Marcus Adams/© Reserved

ROYAL PHOTOGRAPHER

Pages 20 and 21

• J.J.E. Mayall, *Queen Victoria and Princess Beatrice*, May 1860; albumen print (RCIN 2900285)

• Studio Lisa, *Princess Elizabeth and corgis*, 1936; gelatin silver print (RCIN 2305569): Studio Lisa/Camera Press

• *The Duke of York (later King George VI), Princess Elizabeth with lilies*, 1929; gelatin silver print (RCIN 2999926)

• Cecil Beaton, *Princess Elizabeth*, 9 March 1945; gelatin silver print (RCIN 2943811): ©V&A Images/Cecil Beaton

• Baron, *Princess Anne's Christening at Buckingham Palace*, 21 October 1950; gelatin silver print (RCIN 2014204): © Reserved/The Royal Collection

Pages 22 and 23

• *Princess Elizabeth's Christmas card with photograph of Princess Elizabeth and Prince Charles*, 1949; gelatin silver print (RCIN 2943751)

• *Two-handled mug produced to commemorate the Coronation of King George VI and Queen Elizabeth*, 12 May 1937 (RCIN 54035): photograph: The Royal Collection: Royal Albert and Paragon are registered trademarks of the WWRD Group of Barlaston, Stoke-on-Trent, England.

• *The Duke and Duchess of York with Princesses Elizabeth and Margaret*, 7 November 1934; gelatin silver print (RCIN 2943771)

• *Tuck post card envelope*, containing post cards showing Adams portraits of the Duchess of York and Princess Elizabeth, 1928 (RCIN 2943743): © Reserved/The Royal Collection

Pages 24 and 25

• *Princess Elizabeth,* 30 June 1927; gelatin silver print (RCIN 2585303)

• *Cup and Saucer, Souvenir of Princess Elizabeth by Special Permission of Her Royal Highness The Duchess of York*. The words on the saucer read 'Our Empire's Little Princess Born April 21st 1926' (RCIN 54801.a-b): photograph: The Royal Collection: Royal Albert and Paragon are registered trademarks of the WWRD Group of Barlaston, Stoke-on-Trent, England.

• *Tuck post card showing Adams portrait of Prince Charles and Princess Anne*, 24 October 1952 (RCIN 2943746): © Reserved/The Royal Collection

• *Nurse Clara Knight with Princess Elizabeth,* 3 March 1927; reproduced from an original glass plate negative (RCIN 2140640)

• *Prince Charles and Princess Anne in the clothes they wore for their mother's Coronation on 2 June 1953*, photographed on 23 July 1953; colour transparency (RCIN 2943772)

Pages 26 and 27

• *Princess Alexandra of Kent*, 10 April 1940; reproduced from an original glass plate negative (RCIN 2140823)

• *Prince Edward of Kent*, 10 April 1940; reproduced from an original glass plate negative (RCIN 2140825)

• *The Duke of Gloucester with Prince William*, 27 October 1943; gelatin silver print (RCIN 2943734)

• Gilbert Adams, *Marcus Adams reviewing some of his royal portraits with royal biographer Dorothy Laird and photographer Eric Coop*, c.1958; gelatin silver print: © The Estate of Marcus Adams

• *Adams's Royal Warrant from Queen Elizabeth*, 1938 (RCIN 2943774)

PRINCESS ELIZABETH'S FIRST SITTINGS

Pages 28 and 29

• *Princess Elizabeth*, 2 December 1926; gelatin silver print (RCIN 2943585)

• *Princess Elizabeth*, 20 January 1927; gelatin silver print (RCIN 2943705)

Pages 30 and 31

• *Princess Elizabeth*, 2 December 1926; gelatin silver print (RCIN 2943586)

• *The Duchess of York with Princess Elizabeth*, 2 December 1926; gelatin silver print (RCIN 2943581)

• *The Duke of York with Princess Elizabeth*, 2 December 1926; gelatin silver print (RCIN 2999845)

• *Leather double-frame containing two photographs from Princess Elizabeth's first sitting with Adams*, 2 December 1926 (RCIN 2943742): © Reserved/The Royal Collection

Pages 32 and 33

• *Princess Elizabeth playing with Victorian glasses, looking down*, 20 January 1927; gelatin silver print (RCIN 2943706)

• *Princess Elizabeth playing with Victorian glasses, looking up*, 20 January 1927; gelatin silver print (RCIN 2943775)

• *Princess Elizabeth laughing*, 20 January 1927; gelatin silver print (RCIN 2943812)

• *Princess Elizabeth wearing a bonnet*, 20 January 1927; gelatin silver print (RCIN 2943776)

• *Princess Elizabeth looking at pictures of her parents*, 20 January 1927; gelatin silver print (RCIN 2943707)

Pages 34 and 35

• *Princess Elizabeth, back view,* 3 March 1927;
gelatin silver print (RCIN 2943704)

• *Princess Elizabeth,* 3 March 1927; gelatin silver
print (RCIN 2943708)

• *Letter from Allah to the Duchess of York,*
8 March 1927 (RCIN 2943709)

Pages 36 and 37

• *Queen Mary with Princess Elizabeth,* 31 March
1927; gelatin silver print (RCIN 2928711)

• *Princess Elizabeth with a toy tiger,* 6 May 1927;
gelatin silver print (RCIN 2943778)

• *Hand study, Princess Elizabeth,* 6 May 1927;
gelatin silver print (RCIN 2943710)

• *Princess Elizabeth,* 6 May 1927; gelatin silver print
(RCIN 2943777)

Pages 38 and 39

• *The Duke and Duchess of York with Princess
Elizabeth,* 30 June 1927; gelatin silver print
(RCIN 2943604)

• *The Duchess of York with Princess Elizabeth,*
30 June 1927; gelatin silver print (RCIN 2943600)

• *The Duke and Duchess of York with Princess
Elizabeth,* 30 June 1927; gelatin silver print
(RCIN 2943602)

• *Princess Elizabeth standing,* 30 June 1927;
gelatin silver print (RCIN 2943640)

• *Princess Elizabeth, chin in hands,* 5 July 1928;
gelatin silver print (RCIN 2585300)

• Miss Buchanan Scott, *Princess Elizabeth in 1928;*
miniature after RCIN 2585300 (RCIN 421486):
© Reserved/The Royal Collection

Pages 40 and 41

• *Princess Elizabeth,* 5 July 1928; gelatin silver print
(RCIN 2585297)

• Caldesi, *Prince Arthur,* 1857; salted paper print
(RCIN 2900255)

• *Princess Elizabeth,* 5 July 1928; gelatin silver print,
coloured in pastel by Christopher Adams, 1931
(RCIN 2943052)

• *Princess Elizabeth, chin in hands,* 5 July 1928;
gelatin silver print (RCIN 2943649)

• *Princess Elizabeth, smiling, chin in hands,* 5 July
1928; gelatin silver print (RCIN 2943653)

Pages 42 and 43

• *Princess Elizabeth,* 5 July 1928; gelatin silver print
(RCIN 2943780)

• *Princess Elizabeth, chin in hands, looking up,*
5 July 1928; gelatin silver print (RCIN 2943781)

• *Princess Elizabeth laughing,* 5 July 1928;
gelatin silver print (RCIN 2943755)

• *Princess Elizabeth laughing, full-length,*
5 July 1928; gelatin silver print (RCIN 2943779)

Pages 44 and 45

• *The Duke of York with Princess Elizabeth,*
30 July 1929; gelatin silver print (RCIN 2943655)

• *The Duchess of York with Princess Elizabeth,*
30 July 1929; gelatin silver print (RCIN 2943658)

• *The Duke and Duchess of York with Princess
Elizabeth having a tea party,* 30 July 1929;
reproduced from an original glass plate negative
(RCIN 2943782)

• *Princess Elizabeth, full-length,* 30 July 1929;
gelatin silver print (RCIN 2943662)

Pages 46 and 47

• *Four Newfoundland postage stamps featuring Adams
portrait of Princess Elizabeth,* taken 14 November
1929, stamps issued 1932: Reproduced by gracious
permission of Her Majesty The Queen to whom
copyright belongs.

• *Princess Elizabeth,* 14 November 1929;
gelatin silver print (RCIN 2943664)

• *Princess Elizabeth, full-length,* 30 July 1929;
gelatin silver print (RCIN 2943660)

THE ROYAL SISTERS

Pages 48 and 49

• *Princess Elizabeth,* 21 July 1931; reproduced from
an original glass plate negative (RCIN 2140691)

• *Princesses Elizabeth and Margaret,* 15 July 1932;
gelatin silver print (RCIN 2943786)

Pages 50 and 51

• *Princess Elizabeth,* 22 January 1931; gelatin silver
print (RCIN 2943711)

• *The Duchess of York with Princess Margaret,*
2 February 1931; reproduced from an original glass
plate negative (RCIN 2140765)

• *The Duchess of York with Princesses Elizabeth
and Margaret,* 2 February 1931; reproduced from
an original glass plate negative (RCIN 2140774)

Pages 52 and 53

• *The Duchess of York with Princesses Elizabeth
and Margaret,* 22 June 1931; gelatin silver print
(RCIN 2943715)

• *The Duchess of York with Princesses Elizabeth
and Margaret,* 22 June 1931; gelatin silver print
(RCIN 2108293)

• *The Duchess of York with Princess Margaret,*
22 June 1931; gelatin silver print (RCIN 2943712)

• *The Duke of York with Princess Margaret,*
22 June 1931; gelatin silver print (RCIN 2943714)

Pages 54 and 55

• *Princess Margaret wearing a bonnet,* 22 June 1931; gelatin silver print (RCIN 2943713)

• *Princess Margaret,* 22 June 1931; gelatin silver print (RCIN 2943784)

• *Princess Margaret,* 22 June 1931; gelatin silver print (RCIN 2943783)

• *Princess Margaret with flower,* 22 June 1931; gelatin silver print (RCIN 2943785)

• *Princess Elizabeth,* 21 July 1931, card signed and dated by Princess Elizabeth ('Lilibet') in 1932; gelatin silver print (RCIN 2808544)

Pages 56 and 57

• *Princesses Elizabeth and Margaret,* 15 July 1932; gelatin silver print (RCIN 2108787)

• *Princess Margaret,* 15 July 1932; gelatin silver print (RCIN 2943718)

• *Princess Margaret, looking upwards,* 15 July 1932; gelatin silver print (RCIN 2943716)

• *Princess Margaret,* 15 July 1932; gelatin silver print (RCIN 2943788)

• *The Duchess of York with Princess Margaret,* 15 July 1932; gelatin silver print (RCIN 2943717)

Pages 58 and 59

• *Princess Margaret,* 15 July 1932; gelatin silver print (RCIN 2943789)

• *Princess Margaret, chin in hands,* 12 July 1933; gelatin silver print (RCIN 2943719)

Pages 60 and 61

• *Princesses Elizabeth and Margaret,* 12 July 1933; gelatin silver print (RCIN 2943791)

• *Princesses Elizabeth and Margaret,* 12 July 1933, hand coloured with River Thames and Windsor Castle in the background; colour transparency (RCIN 2943790)

• *Princess Margaret,* 12 July 1933; gelatin silver print, hand coloured (RCIN 2943756)

Pages 62 and 63

• *Princess Elizabeth,* 1 November 1934; gelatin silver print (RCIN 2943721)

• *The Duchess of York with Princesses Elizabeth and Margaret,* 7 November 1934; gelatin silver print (RCIN 2108296)

• *Princesses Elizabeth and Margaret,* 7 November 1934; gelatin silver print (RCIN 2943793)

Pages 64 and 65

• *Princess Elizabeth seated, with a doll,* 13 December 1935; gelatin silver print (RCIN 2943724)

• *Princess Margaret seated, with a doll,* 13 December 1935; gelatin silver print (RCIN 2943726)

• *Portrait of the two dolls,* 13 December 1935; gelatin silver print (RCIN 2943725)

• *Princess Margaret, full-length,* 13 December 1935; gelatin silver print (RCIN 2943722)

• *Princess Elizabeth seated, with a toy cat,* 13 December 1935; gelatin silver print (RCIN 2943794)

Page 66

• *Princesses Elizabeth and Margaret, full-length,* 13 December 1935; gelatin silver print (RCIN 2943795)

GROWING UP

Page 67

• *Princess Elizabeth, looking over right shoulder,* 18 March 1941; reproduced from an original glass plate negative (RCIN 2140904)

Pages 68 and 69

• *King George VI and Queen Elizabeth with Princesses Elizabeth and Margaret,* 15 December 1936; gelatin silver print (RCIN 2999914)

Pages 70 and 71

• *Queen Elizabeth with Princesses Elizabeth and Margaret,* 15 December 1936; gelatin silver print (RCIN 2943796)

• *Princess Elizabeth, looking over left shoulder,* 15 December 1936; gelatin silver print (RCIN 2943797)

• *Princess Margaret, looking over left shoulder,* 15 December 1936; gelatin silver print (RCIN 2943798)

• *Princess Elizabeth, head and shoulders,* 15 December 1936; gelatin silver print (RCIN 2943727)

Pages 72 and 73

• *The Royal Family, including Dookie, at Buckingham Palace,* 20 December 1938; gelatin silver print (RCIN 2943768)

• *Princess Elizabeth with Dookie,* 20 December 1938, hand coloured; colour transparency (RCIN 2943799)

Pages 74 and 75

• *Princesses Elizabeth and Margaret,* 16 February 1939; gelatin silver print (RCIN 2943729)

• *Princess Margaret,* 16 February 1939; gelatin silver print (RCIN 2943728)

Pages 76 and 77

• *Princesses Elizabeth and Margaret*, 9 April 1940; gelatin silver print (RCIN 2943730)

• *Princess Elizabeth wearing a kilt*, 9 April 1940; gelatin silver print (RCIN 2943757)

• *Queen Elizabeth with Princesses Elizabeth and Margaret*, 9 April 1940; gelatin silver print (RCIN 2943803)

Pages 78 and 79

• *Queen Elizabeth with Princesses Elizabeth and Margaret, at Windsor Castle*, 18 March 1941; gelatin silver print (RCIN 2943802)

• *Princesses Elizabeth and Margaret with Dookie, at Windsor Castle*, 18 March 1941; gelatin silver print (RCIN 2943731)

• *Princesses Elizabeth and Margaret working on a jigsaw puzzle, at Windsor Castle*, 18 March 1941; gelatin silver print (RCIN 2943801)

A NEW GENERATION

Pages 80 and 81

• Unknown photographer, *Prince Charles arriving at 43 Dover Street, c.*1952; gelatin silver print: The Estate of Marcus Adams/© Reserved

• *Marcus Adams with Prince Charles and Princess Anne, c.*1953; reproduced from an original glass plate negative (RCIN 2943805)

Pages 82 and 83

• *Prince Charles*, 26 October 1949; reproduced from an original glass plate negative (RCIN 2140973)

• *Princess Elizabeth with Prince Charles*, 26 October 1949; colour transparency (RCIN 2943737)

• *Post card with New Zealand Health Stamps featuring Adams portrait of Princess Elizabeth with Prince Charles,* taken 26 October 1949, stamps issued in 1950: Reproduced by gracious permission of Her Majesty The Queen to whom copyright belongs.

• *New Zealand Health Stamp featuring Adams portrait of Prince Charles,* taken 29 October 1951, stamps issued in 1952: Reproduced by gracious permission of Her Majesty The Queen to whom copyright belongs.

• *New Zealand Health Stamp featuring Adams portrait of Princess Anne,* taken 26 July 1951, stamps issued in 1952: Reproduced by gracious permission of Her Majesty The Queen to whom copyright belongs.

• *Prince Charles sitting cross-legged*, 29 October 1951; reproduced from an original glass plate negative (RCIN 2141024)

Pages 84 and 85

• *Princess Anne*, 15 July 1952; reproduced from an original glass plate negative (RCIN 2141043)

• *Prince Charles and Princess Anne*, 24 October 1952; gelatin silver print (RCIN 2014220)

• *Tuck post card showing Adams portrait of Prince Charles and Princess Anne*, 24 October 1952 (RCIN 2943745): © Reserved/The Royal Collection

Pages 86 and 87

• *Prince Charles, full-length*, 29 October 1953; reproduced from an original glass plate negative (RCIN 2141119)

• *Prince Charles*, 29 October 1953; reproduced from an original glass plate negative (RCIN 2141107)

• *Princess Anne*, 12 April 1954; gelatin silver print (RCIN 2943739)

• *Prince Charles and Princess Anne*, 12 April 1954; gelatin silver print (RCIN 2943740)

• *Prince Charles and Princess Anne standing against a measuring stick*, 12 April 1954; gelatin silver print (RCIN 2943144)

• *Prince Charles,* 12 April 1954; gelatin silver print (RCIN 2943741)

Pages 88 and 89

• *Princess Anne*, 20 July 1954; colour transparency (RCIN 2943736)

• *The Queen with Prince Charles and Princess Anne*, 6 November 1954; colour transparency (RCIN 2943738)

Page 90

• *Princess Anne*, 20 July 1956; reproduced from an original glass plate negative (RCIN 2140375)

ROYAL RELATIVES

Page 91

• *Prince Edward of Kent*, 21 June 1937; reproduced from an original glass plate negative (RCIN 2140536)

Pages 92 and 93

• *The Infanta Beatriz of Spain*, 5 May 1922; reproduced from an original glass plate negative (RCIN 2141298): © The Estate of Marcus Adams

• *The Infanta Maria Cristina of Spain*, 5 May 1922; reproduced from an original glass plate negative (RCIN 2141306): © The Estate of Marcus Adams

• *The Infantas Beatriz and Maria Cristina of Spain*, 5 May 1922; gelatin silver print (RCIN 2807054): © The Estate of Marcus Adams

Pages 94 and 95

• *Lady Glamis with Timothy and Nancy Bowes Lyon*, 11 March 1924; gelatin silver print (RCIN 2943760): © The Estate of Marcus Adams

• *Timothy Bowes Lyon*, 11 March 1924; gelatin silver print (RCIN 2943761): © The Estate of Marcus Adams

• *Nancy Bowes Lyon*, 11 March 1924; gelatin silver print (RCIN 2943759): © The Estate of Marcus Adams

Pages 96 and 97

• *Princess Paul of Yugoslavia with Prince Nikola*, 28 November 1934; reproduced from an original glass plate negative (RCIN 2141452): © The Estate of Marcus Adams

• *Prince Nikola of Yugoslavia*, 28 November 1934; reproduced from an original glass plate negative (RCIN 2141461): © The Estate of Marcus Adams

• *The Duchess of Kent with Prince Edward*, 17 February 1936; gelatin silver print (RCIN 2806310)

Pages 98 and 99

• *The Duke and Duchess of Kent with Prince Edward*, 7 October 1936; gelatin silver print (RCIN 2806301)

• *Prince Edward of Kent*, 21 June 1937; gelatin silver print (RCIN 2943735)

• *Princess Alexandra of Kent*, 21 June 1937; gelatin silver print (RCIN 2943733)

• *Prince William of Gloucester playing with a teddy*, 27 October 1943; reproduced from an original glass plate negative (RCIN 2141332)

• *Prince William of Gloucester*, 27 October 1943; gelatin silver print (RCIN 2943773)

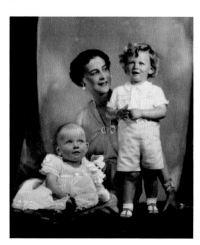

ROYAL PORTRAITS BY BERTRAM PARK

Pages 100 and 101

• Bertram Park, 31 March 1927; reproduced from an original glass plate negative (RCIN 2140662): © The Estate of Marcus Adams

• Bertram Park, *Lady Elizabeth Bowes Lyon*, 31 January 1922; gelatin silver print (RCIN 2943427): Bertram Park/Camera Press/© The Estate of Marcus Adams

Pages 102 and 103

• Bertram Park, *Lady Elizabeth Bowes Lyon*, 31 January 1922; gelatin silver print (RCIN 2943425): Bertram Park/Camera Press/© The Estate of Marcus Adams

• Bertram Park, *The Duchess of York*, 30 July 1929; gelatin silver print enhanced with crayon and stumping chalk (RCIN 2943412): Bertram Park/Camera Press/© The Estate of Marcus Adams

Pages 104 and 105

• Bertram Park, *King George VI*, 15 December 1936; gelatin silver print (RCIN 2943808): Bertram Park/Camera Press/© The Estate of Marcus Adams

• Bertram Park, *Queen Elizabeth*, 15 December 1936; gelatin silver print (RCIN 2943807): Bertram Park/Camera Press/© The Estate of Marcus Adams

Pages 106 and 107

• Bertram Park, *Queen Victoria Eugenia of Spain*, November 1919; gelatin silver print (RCIN 2807093): Bertram Park/Camera Press/© The Estate of Marcus Adams

• Bertram Park, *Princess Paul of Yugoslavia*, 28 November 1934; gelatin silver print (RCIN 2929233): Bertram Park/Camera Press/© The Estate of Marcus Adams

Page 108

• *One of Marcus Adams's presentation folders* (RCIN 2943749): © The Estate of Marcus Adams

Page 113

• *Marcus Adams's box of artist's materials:* © The Estate of Marcus Adams

Pages 118 and 119

• *A glass plate negative showing the Duchess of York with Princess Elizabeth*, 5 July 1928 (RCIN 2943767), *and a box of Barnet Plates* (RCIN 2943754)

• *Princess Marina, Duchess of Kent with Prince Edward and Princess Alexandra*, 21 June 1937; reproduced from an original negative (RCIN 2140586)

INDEX

Page numbers in *italics* refer to illustrations.

Adams, Annie 6
Adams, Christopher 7, 17, 40
Adams, Gilbert *7*, 8, 24
 Marcus Adams, Eric Coop and Dorothy Laird 27
Adams, Lilian 7
Adams, Lily Maud (*née* Farr) 8, 17
Adams, Marcus *7, 12, 15, 19, 27, 81*
 cameras 12, 13, 17, 18, *19*
 'Early Days' 7
 family tree 112
 negative books 14, *14*, 16, 108
 'phase photography' 9, *9*
 presentation folder *108*
 The Rhythm of Children's Features 18
 Royal Warrant 27, *27*
 Self-portrait 2
Adams, Walton 6, 7, *7*, 11
Alexandra of Kent, Princess (Hon. Lady Ogilvy)
 25, *26*, 98, *98*, 109, *119*
Anne, Princess 17, *21*, 24, *24*, 24–5, *25*, 27, 82, *83–5*,
 87–90
Armstrong Jones, Antony *see* Snowdon, Earl of
Arthur, Prince *40*
Asquith, Herbert Henry 8
Astor, Lady Violet 14

Barge on the River Thames, Reading 8
Baron 20, 25
 Princess Elizabeth, Duke of Edinburgh and
 Princess Anne 21
Beaton, Cecil 20
 Princess Elizabeth 21
Beatrice, Princess *20*, 92, 106
Beatriz, Infanta of Spain 25, 92, *92, 93*, 106
Bennett, Sylvia 22–3
Bethlehem street scene 16, 17
Bowes Lyon, The Hon. Nancy 94, *94, 95*
Bowes Lyon, The Hon. Timothy 94, *94, 95*
Buzzard, Frank 10

Caldesi, Leonida: *Prince Arthur* 40
Camera Club, The 10
Carnarvon, George Herbert, 5th Earl of 10, 11
Charles, Prince *12*, 17, *22*, 22–5, *24, 25*, 80–4,
 85–7, 86, 87, 89
Children's Studio, The (London) 12, 14–16, 18, 22, 36
 logos *13*
Children's Studio, The (Reading) 8, *9*
Christie, Agatha 16
Coop, Eric 27
cup, souvenir *24*

Dookie *72, 73, 79*

Edinburgh, Duke of *see* Philip, Prince
Edward VIII 25, 68
Edward, Prince, Duke of Kent 25, *26, 91*, 97, *97*,
 98, 119
Elizabeth II 8, 26–7, *89*
 1926–29 14, 18, *18*, 21, *21*, 24, *24–5, 28–47*
 1931–35 *23, 48–52, 55, 56, 60, 62–6*
 1936–45 17, *20*, 21, *67–74, 76–9*
 1949–54 *21, 22*, 22–3, *82, 83*
Elizabeth, Queen Consort *23*, 27, *69, 70, 72,*
 77–78, 105
 as Lady Elizabeth Bowes Lyon 21, *101, 102*
 as Duchess of York 21, 25, *31*, 32, 34, 37, *38, 44*,
 51, *52–3*, 57, *57, 63, 103*
Elizabeth Is Queen 26–7

'Fairy Girl, The' 9

George II, of the Hellenes 26
George V 8, 36, 68, 86
George VI *23, 68, 72, 104*
 as Duke of York 21, 25, *31*, 32, *38, 44*, 53
 Princess Elizabeth with lilies 21
George, Prince, Duke of Kent 26, 97, *98*, 107
Glamis, Dorothy, Lady *94*
Glamis, Patrick, Lord 94
Gordon, General Charles 6, *6*
Gregory, Yvonne (Mrs Park) 10–11, 14
Guinness, Lady Evelyn 14

Henry, Prince, Duke of Gloucester 25, *26*, 99

Illustrated London News 14
Isaacs, Sir Rufus 8

Kent, Duchess of *see* Marina, Princess
Kent, Duke of *see* George, Prince
Keyser, Charles 7–8
Knight, Clara 24, *25*, 35, 36
 letter to the Duchess of York *35*

Laird, Dorothy *27*
Lawrence, Gertrude 16
Lightbody, Helen 22, 24–25
Listener, The 6, 13, 56
Lloyd George, David 8
London Salon of Photography 8–9, 19

Maddox, Dr Richard Leach 6
Margaret, Princess
 1930–35 *49*, 51, *51–4, 56–61, 63, 64, 65*
 1936–41 17, *69, 70, 72, 74–9*
Maria Cristina, Infanta of Spain 25, 92, *92, 93*, 106
Marie, Queen of Yugoslavia 26

Marina, Princess, Duchess of Kent 26, 96, 97, *97*,
 98, 107, *119*
Mary, Queen 8, 25, 36, *36*
Mayall, J.J.E. 20
 Queen Victoria and Princess Beatrice 20
Menuhin, Yehudi 16
Milne, Mrs A.A. 16
mug, Coronation *23*

Nazareth street scene 16, 17
Newfoundland stamps *46*
New Zealand health stamps *83*
Nikola, Prince, of Yugoslavia 25, 96, *96*, 107

Olga, Princess (Princess Paul), of Yugoslavia 25, 96,
 96, 107

Park, Bertram 10–11, 14, 19, 20, 22, 25, *100*
 The Duchess of York 103
 King George VI 104
 Lady Elizabeth Bowes Lyon 101, 102
 Princess Paul of Yugoslavia 107
 Queen Elizabeth 105
 Queen Victoria Eugenia of Spain 106
Peter, King of Yugoslavia 26
Philip, Prince, Duke of Edinburgh *21*, 82
Photograms of the Year 9, *11*

Ronaldshay, Countess of 14
Royal Flying Corps 9–10

Sandringham Church 7, *7*
Scott, Miss Buchanan 39
Sketch 14
Snowdon, Earl of 13
Speaight Ltd 20
Strathmore, 15th Earl of *see* Glamis, Patrick, Lord
Strathmore, 16th Earl of *see* Bowes Lyon, Timothy
Studio Lisa 20
 Princess Elizabeth and corgis 20
'Sunshine Boy, The' 9

Tuck (Raphael) & Sons Ltd: postcards *23, 24*, 84, *85*

Vacani, Madame 16–17
Venice: St Mark's Square 17
Victoria, Queen 6, 20, *20*, 40, 92, 106
Victoria Eugenia, Queen of Spain 26, 92, 106, *106*

William of Gloucester, Prince 25, *26*, 99
'Winding up my aeroplane' 10

York, Duchess of *see* Elizabeth, Queen Consort
York, Duke of *see* George VI
Young girl from Reading 8